M000035360

IMAGES
*of America*

# BOERNE

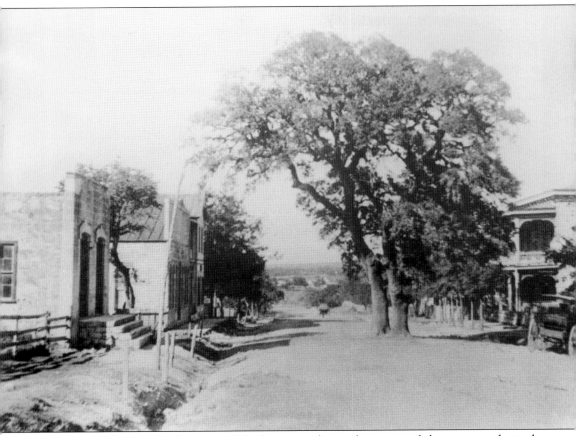

Boerne residents evidently treasured shade trees and even drove around these giant oaks in the middle of Main Street in 1910. On the left is the old Weyrick-Coryell-Beissner Building, next to Phillip Manor. On the right is the Mansion House, which was owned by a long list of prominent families in Boerne and which evolved into several popular restaurants. (Courtesy Boerne Public Library Archives Collection.)

ON THE COVER: From 1898, Christian and Lawrence Schrader operated Boerne Livery Stable for 20 years, until the arrival of automobiles. Henry Fabra recollected, "On Sunday afternoons we boys would go and get a horse and buggy and take our girls out riding. And the horses that you didn't have to use reins with were always in demand." (See page 56 for the full photograph.) (Courtesy Boerne Public Library Archives Collection.)

IMAGES
*of America*

# BOERNE

Brent Evans

ARCADIA
PUBLISHING

Copyright © 2010 by Brent Evans
ISBN 978-0-7385-7943-6

Published by Arcadia Publishing
Charleston, South Carolina

Printed in the United States of America

Library of Congress Control Number: 2010928315

For all general information, please contact Arcadia Publishing:
Telephone 843-853-2070
Fax 843-853-0044
E-mail sales@arcadiapublishing.com
For customer service and orders:
Toll-Free 1-888-313-2665

Visit us on the Internet at www.arcadiapublishing.com

*This book is dedicated to all the folks who have worked
to preserve the cultural history and natural wonder
that make Boerne home—especially Carolyn.*

# CONTENTS

# ACKNOWLEDGMENTS

Bettie Edmonds has enlivened this project, and so much more. She has championed local historic preservation with amazing energy. Edmonds has sketched homesteads and historic buildings and enabled families to bring their histories to the library to be preserved. Her passion for organizing the archive collection, preserving the memories, telling the stories, and showing the pictures has provided our town with a real sense of place. What a legacy!

Paul Barwick is a founder of Friends of Old No. 9, a landscape architect, and senior planner for the City of Boerne Planning Department. Paul wrote the "Routes, Rails, and Roads" chapter and collaborated with great research. He authors the upcoming Arcadia book *Kendall County*. Big thanks to the *Boerne Star*, the Boerne Visitor Center, the Friends of Old No. 9, the Cibolo Conservancy Land Trust, Charlie Wetherbee, and Josué Martinez.

When Arcadia Publishing approached me about this project, I knew I was not a real historian. (For a more comprehensive history of Boerne, read Jefferson Morgenthaler's *Boerne: Settlement on the Cibolo* and *The German Settlement of the Texas Hill Country*: mega hours of research and fun reads.) But the temptation to pour through the old pictures and stories in the archives just became too much for me. The archives are precious, full of priceless remnants of people's hopes and dreams and heartbreaks and lives. The Boerne Public Library Archives Collection is the source for all images in this book, unless otherwise noted. All profits from the royalties from this book will be donated to the archives.

This is an admittedly very personal journey back through time. Thanks to my family for tolerating my latest obsession. And thanks to Jonah and Laurel for helping Dad again. Most of all, thanks to Carolyn for this passion we share.

It turns out that Boerne has been a rowdy little town from the get go. The newcomers were escapees who decided to stay. They were feisty and finicky and persistent and not always polite. But, in frontier times, the future of Boerne depended on them finding ways to work together and listen to each other. It still does.

I found valuable information while writing the book in Col. Bettie Edmonds's *Along Country Roads . . . in the Texas Hill Country, Volumes I and II* (Hart Graphics, 1980) as well as from Edmonds's *A History of Kendall County, Texas—Rivers, Ranches, Railroads, and Recreation* (Taylor Publishing Company, 1984). I referred to *Reminiscences: Stories of a Country Girl* by Frankie Davis Glen (Nortex Press, 1994). I gleaned information from two books by members of the Herff family: Dr. Ferdinand von Herff's *The Regulated Emigration of the German Proletariat with Special Reference To Texas, Being Also a Guide for German Emigrants* (Franx Varrentrapp Publishing Company, 1850, and translated Arthur L. Fink Jr., 1949); and *The Doctors Herff: A Three-Generation Memoir* by Ferdinand Peter Herff (Trinity University Press, 1973). Irene Marschall King's 1987 book *John O. Meusebach: German Colonizer in Texas* (University of Texas Press) was helpful, as were two books from Jefferson Morgenthaler: *Boerne: Settlement on the Cibolo* (2005) and *The German Settlement of the Texas Hill Country* (2007), both published by Mockingbird Books in Boerne.

Other sources used were Frederick Law Olmsted's *A Journey through Texas* (University of Texas Press, 1978); Garland Perry's *Historic Images of Boerne and Kendall County, Texas* (Perry Publications, 1998); *Roemer's Texas* by Ferdinand Roemer (Eakin Press, 1995); Clinton L. Smith's *The Boy Captives* (San Saba Printing, 1955); and two books by Del Weniger: *The Explorers' Texas—The Lands and Waters* (Eakin Press, 1984) and *The Explorers' Texas Volume 2: The Animals They Found* (Eakin Press, 1997).

# INTRODUCTION

Welcome to Boerne, a little town with plenty of character, or more to the point, characters. Boerne was born out of a collision of cultures in the wild hills of Texas, where a few folks were stubborn enough to settle down and make the best of it. Many Native Americans, Mexicans, and Spaniards were here before the photographic record begins. As Mark Twain notes in his essay "The Lowest Animal," "Man is the only animal that robs his helpless fellow of his country—takes possession of it and drives him out of it or destroys him. . . . There is not an acre of ground on the globe that is in possession of its rightful owner." Texas was no exception.

Long ago, there was a primitive "interstate" network of trade routes through the Texas hills, including the "Camino Viejo" - or "Old Road". Early explorers and settlers named a little stream that flowed from the hills on to the San Antonio River and eventually the Gulf of Mexico the Cibolo, meaning buffalo. But it turns out that the word was probably a joke. Historian Jefferson Morgenthaler traces the origins of the word *cibolo* to the failed 1540 expedition by Coronado to find the legendary Seven Cities of Cibola, a legendary gold-laden, jewel-encrusted empire. Coronado found no gold with the Zunis in New Mexico or anywhere else. Spanish troops began sarcastically calling the thousands of buffalo that they found on their journey—previously known as *vacas*, or cows—cibolas. *Cibola* is now Spanish for a buffalo cow; *cibolo* is the bull. A 1718 Spanish map depicts the Arroyo Sibulo in this area. In 1836, José Enrique de la Peña reported, "I advanced to Cibolo Creek, and I saw hundreds of buffalo in herd."

To encourage settlement, Mexican authorities allowed organized immigration, and by 1834, they estimated that the Texas territory had over 30,000 Anglos, 7,800 Mexicans, and almost 7,000 slaves. During the Texas Revolution in 1835, Capt. Ben Milam confronted 100 Mexican cavalry near Cibolo Creek and forced them to retreat back to San Antonio—"this little skirmish . . . was regarded as a favorable omen," wrote Milam. But, in 1836, the siege of the Alamo ended with 180 defenders killed. In the same year, the decisive battle at San Jacinto resulted in Santa Anna's defeat, paving the way for Texas Independence. Many Mexican settlers in Texas had opposed Santa Anna's brutality and joined with the Texans, proudly proclaiming, "We are Tejanos!"

Land speculation in the Cibolo Valley grew, and Germans became interested. Europe had been seized with food shortages, famine, diseases, wars, and revolutionary fervor. Alexis de Tocqueville remarked in his recollections of the period that "society was cut in two: those who had nothing united in common envy, and those who had anything united in common terror." The German's "Nobles Society" promised strong financial assistance and fertile farmland for immigrants. But it was out of the frying pan and into the fire for the unfortunate souls. Arriving on the mosquito infested shores of Texas, they found themselves in a wilderness survival situation. There was little support from the Nobles Society, and the land they had been promised was difficult to farm, and occupied by hostile Indians.

The 1847 Bettina colony on the Llano River succeeded in bringing in a first harvest, but it was not enough. Hardships were underestimated, provisions were inadequate, and the colony disintegrated. Five settlers temporarily landed in Sisterdale and then moved farther south, joined three more Germans, and founded Tusculum in 1849 where the ancient Camino Viejo met up with the Rio Cibolo. This was the beginning of Boerne. Meanwhile, another Bettina settler, Dr. Ferdinand Herff, was back in Frankfurt, Germany, publishing *The Regulated Emigration of the German Proletariat, Being Also a Guide for German Emigrants*. This was a long list of lessons learned from Bettina: instructions and warnings, including the necessary tools and supplies, and detailed estimates of manpower needs and financial requirements. "A twenty family colony would

7

need to build twenty block-houses, break 200 acres of land and plant and cultivate corn for their own use; fence in those acres, plant and cultivate 50 acres of corn to furnish provisions for the second shipment of colonists, and build a good cattle corral of at least one-half acre in size. The houses would require one thousand logs, fifty per house, 400 rafters and 800 boards, and thatch and wattle for roofing. To enclose the 200 acres of field would require 12,600 fence rails, and 3,800 stakes and riders." He called for the "colonization of Texas."

By the 1850s, Main Plaza was the place for trading goods and watering livestock. Pioneers built houses using native limestone rocks and cypress timbers. In 1856, Texas Rangers were stationed in Boerne because of Native American raids. In the 1860s, many Germans felt no allegiance to the Confederacy. Unlike most Texans, Boerne's precinct voted 85 to 6 against secession. A local Confederate-leaning rancher wrote this account in 1862: "Back from Boerne with the news. There has been a considerable battle near Richmond in which the Confederates whipped the Yankees. Stonewall Jackson has got in the rear of McClellan's army and he is in a bad fix. . . . There are believed to be a considerable body of men up in Fredericksburg, at least 300 who may give trouble. . . . I may be enrolled among the conscripts and will not be able to get a physician's certificate of inability, as I understand they will not take Dr. Herff's in San Antonio." Confederate troops entered Kendall County in 1862 to punish those who would avoid conscription. Under the "Take No Prisoners" policy of Confederate captain James Duff, a number of "rebellious" locals were killed. The Herff farm was commandeered into a prisoner-of-war camp, the cypress trees along the Cibolo were cut down, livestock were confiscated, and the house was burned to the ground.

In 1863, the Confederate rancher wrote this letter: "You have no idea what a chance we missed. We could have easily converted our negroes into cotton and realized from them $100,000. But, that time is past." By 1870, he wrote: "Indians are in the country all the time. During, the past week, dark of the moon, they have stolen horses all around us. I am afraid to turn the horses out to graze. No one will venture to purchase property on the frontier. Town lots in Boerne have increased in value, but no one will look at land outside Boerne." His last letter was in 1874: "Having no servant we are all over worked. I am always so tired from working in the garden I am scarcely able to sit when in the house" (from "Woolford's Tales," *San Antonio Light*, March 29, 1959).

The 1870s were marked by cattle drives by new English settlers, the first school in Boerne, and the construction of the Kendall County Courthouse. In 1875, the first newspaper, the *Union Land Register*, was started. The First United Methodist Church was founded in 1876. Steam engines roared into Boerne on rails in the late 1880s, and the town became a health spa because of its "clean mountain air and water." In 1909, the farming and ranching town incorporated with a population of 885. Over 80 years, the population slowly grew to 2,400. In the following 40 years, Boerne's growth accelerated, producing a population of over 11,000 today.

The Camino Viejo Trail is gone now, and most of the old pioneer houses and farms have disappeared. But the songs and stories and legends live on. Hopefully this photo album can capture a few of the characters and places that have made our town something special. And as the town grows, hopefully it can hold on to its cultural and natural heritages.

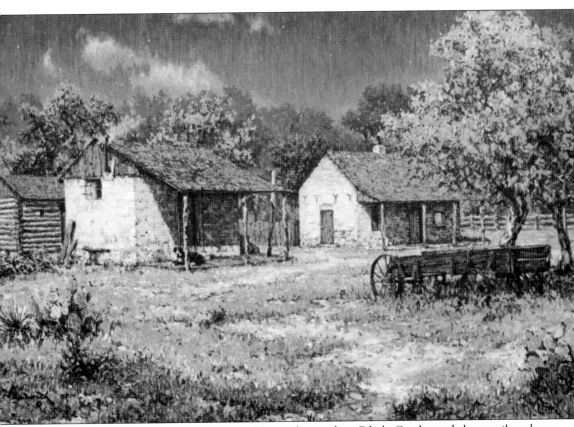

Where the Camino Veijo (the "Old Road") met the winding Cibolo Creek, sandy loam soil made for sweet farmland and a new colony, Tusculum. After the failure of Bettina, settlers had still not given up. As Morgenthaler notes, "Almost unbelievably, they were attempting to found another commune." This painting by Mark Haworth of Fredericksburg depicts the old village complex, with portholes for protection from Native Americans. They built their settlement near what is now H. W. Schwope and Sons water well company on Johns Road. The Germans regarded themselves as freethinkers, rejecting the dogma of the church and believing in "the rights of man and tolerance among men." Noblemen among the settlers gave up their titles and became frontiersmen who rejected slavery and insisted on making decisions through consensus.

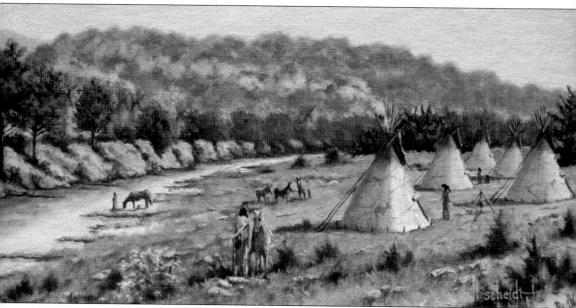

Before Europeans arrived, many native tribes lived, traded, and traveled in this wildlife-rich area. When exploring the Llano and San Saba Rivers in 1684, Juan Dominguez Mendoza wrote "the number of buffalo is so great that only the divine Majesty, as owner of all, is able to count them." Mendoza's party claimed to have killed 4,030 in one place in that area. The widespread massacre of buffalo also massacred the Native American way of life. Superb horseback hunters and warriors, the Comanches spilled out of the Rocky Mountains and moved into Texas in the early 1700s. On March 19, 1840, a prisoner-exchange council meeting with the Texas Army in San Antonio emotionally erupted, and many Comanche were killed or captured. The word went out among the Comanches that Texans could not be trusted. (Courtesy of artist Bill Scheidt.)

# *One*

# BEGINNINGS

The Hill Country was hunting grounds for the Comanche, Lipan Apache, Kiowa, and Tonkowa people. The land was rich in wildlife. Deer, antelope, turkey, and bison were abundant, and black bear and mountain lion roamed. The rivers ran with fish, and the bottomlands were fertile. Native Americans and Mexican pioneers traveled well-worn creek-to-creek trade routes.

In 1847, German immigrants landed at Indianola expecting adequate supplies and support from the Adelsverein (The Nobles Society) but were greeted with news of the war between Mexico and the United States. Supplies were scarce; disease was rampant. The Nobles Society did send a representative, John Meusebach, to settle up to 5,000 colonists in an inhospitable land that was largely occupied by Native Americans.

His small group struggled to New Braunfels under severe hardships, but there were few accommodations. So, against strong advice, Meusebach traveled with 40 men toward the Llano River and rode into a large Comanche camp, ordering his men to discharge their single shot rifles into the air. Meusebach wrote, "Although the fact that the Germans discharged their guns at the meeting with the Comanche was considered imprudent and seemed to show an entire lack of understanding of Native American character, it was the best policy or course action which could have been followed. Several hundred warriors faced us and great numbers were behind us. Each one was well armed—many with guns, a number with spears, and all with bow and arrows. Had it been their purpose to kill us, it would have come to hand-to-hand combat. In this our guns would have been useless and only our pistols and Bowie knives would have served for our defense. So why should we not show confidence?" The Treaty That Was Never Broken involved payment of $3,000, mutual security agreements, rules against horse stealing, and agreement that settlers would always provide meals for visiting Comanche. Immigrants felt reassured by the news, but the treaty did not include many local indigenous groups, and skirmishes and raids continued for years. The treaty is celebrated annually by German and Comanche descendants in Fredericksberg.

According to Frankie Davis Glenn, Meusebach proposed: "We have come a long way to smoke the peace pipes with the Comanche. . . . I want to bring some of my people to the Llano River a make a settlement. We will plant corn and raise cattle and then our red brothers will have something to eat when the buffalo hunt fails." (Courtesy Dicy Glenn Ormiston.) Ferdinand Roemer was there. He wrote, "In the twilight, a number of mounted men appeared before our camp in festive, but most peculiar attire. The faces were painted red and the majority of them wore the peculiar

headdress made of buffalo skin with the horns of buffalo attached. In one hand they carried the long lance, painted red, in the other a round shield made of tanned buffalo hide, painted in gaudy colors and decorated with a circle of feathers. Horses were mostly light in color, their heads and tails were painted a carmine red. The dissatisfied master of a young Mexican captive woman offered her to us for the small sum of forty dollars." (Rare original drawing by Wilhelm Friedrich, Courtesy Juanita Chipman.)

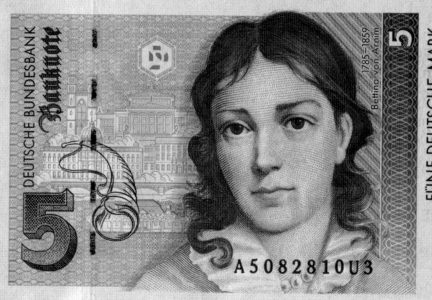

In 1847, forty Freethinkers settled at the confluence of Elm Creek and Llano River but were ill prepared and disbanded within a year. They named their colony Bettina, in honor of Bettina Brentano von Arnim, a writer, illustrator, publisher, singer, visual artist, and composer who passionately advocated for social reform, artistic expression, and compassion for the poor and the oppressed Jews in Germany. She fostered relationships with Beethoven, Goethe, Schumann, Liszt, Brahms, and the king of Prussia. "It is no use telling me to be calm; to me that conveys sitting with my hands in my lap, looking forward to the broth we are having for supper. . . . My soul is a passionate dancer; she dances to hidden music which only I can hear. . . . Whatever police the world may prescribe to rule the soul, I refuse to obey them." Arnim contributed her time and money to relieve the desperate living conditions of the underprivileged throughout her life. Her fame in Germany spread, and her portrait eventually showed up on the Deutsche Mark in 1991.

14

Tusculum was named after the country home of Cicero, the philosopher who saw the role of the virtuous man as "balancing public responsibility and private satisfactions." As with Bettina, colonists had chosen a philosophical name for their settlement. In 1854, traveling journalist Frederick Law Olmsted visited Tusculum, which had been renamed Börne: "In the larger valleys, were groves of post-oak, and along the principal water-courses, timber of various kinds, and some good bottom-land, as on the Cibolo, at the road-crossing, where a town called Börne had been laid out, and a few houses built. But the natural use of the country was, palpably, for grazing, and that, sheep-grazing. We could hardly refrain from expecting, on each bleak hill, to startle a black-faced flock, and see a plaided, silent, long-legged shepherd appear on the scene." Above are remnants of Tusculum.

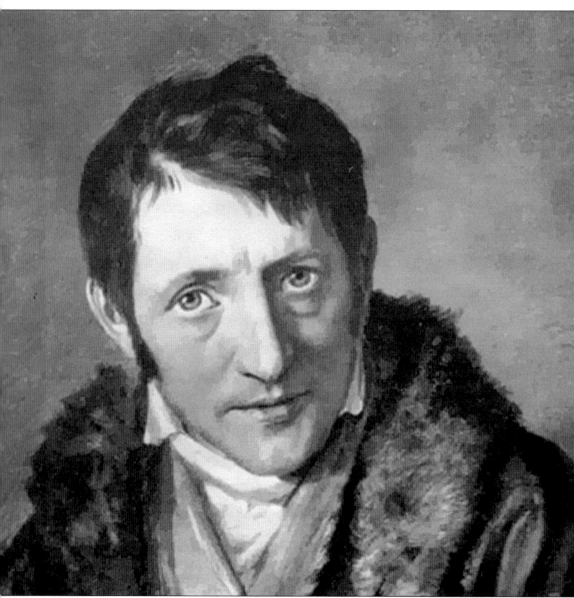

Ludwig von Börne was born Lob Buruch in 1786, an Orthodox Jew in the ghetto of Frankfurt, Germany. He changed his name and traveled to Paris in 1830 and remained there until his death in 1837. His writings criticized the oppressive political order, supported popular freedom movements, and were widely read among the German Freethinkers who founded and settled in Boerne. "Every man has a right to be a blockhead, but even that right should be exercised with modesty; the Germans abuse it," wrote Börne. He also wrote, "Nothing is permanent but change, nothing is constant but death. Every pulsation of the heart inflicts a wound, and life would be an endless bleeding, were it not for Poetry. She secures to us what Nature would deny; a golden age without rust, a spring which never fades, cloudless prosperity and eternal youth." Börne became Boerne because printers placed an *e* after a vowel with an umlaut when there were no umlauts available for the printing press. The local pronunciation, "Bernie," is just an anglicization.

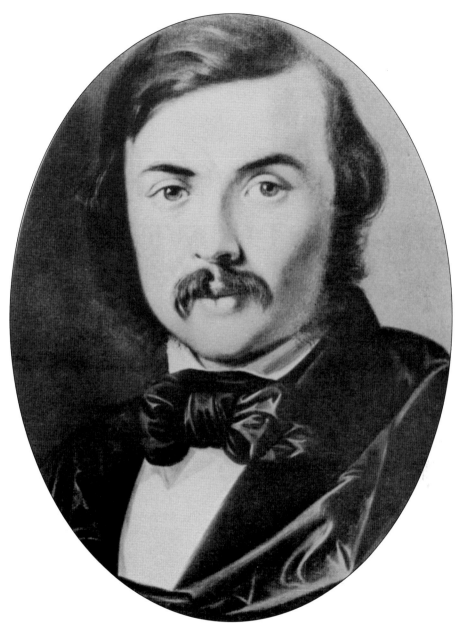

Dr. Ferdinand Ludwig von Herff was born in Darmstadt, Germany, in 1820. He participated in the Bettina experiment, where his surgical skills were valued. After Bettina, his published guide for German emigration and colonization in Texas, including meticulous detailing of all the necessary tools and supplies and skills, was of greater value to the colonization effort. Having learned from Bettina's mistakes, he counseled, "Only in rare cases and with the greatest exertion will the woods farmer produce the following summer a harvest sufficient for his needs from the one acre which he can clear and prepare during the first year; in most cases he must be provided with provisions for an additional year . . . he must also build a house and provide hay for cattle. . . . Texas has up to now been the only region where a grandiose colonizing undertaking has been accomplished and has succeeded at least to the extent that large districts have been cultivated, towns founded in the wilderness, and thousands of Germans guided to an independent and happy station in life."

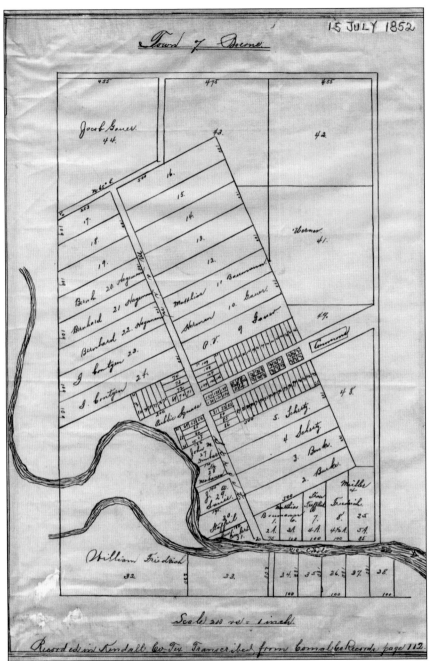

Before the Germans arrived, land was owned through grants from the king of Spain, then the government of Mexico, and later that of Texas for service in the war with Mexico. German settlers began buying parcels, as seen in this 1852 map. By 1858, there were still only 10 houses in Boerne, including the center section of Ye Kendall Inn, the Theis House, a section of the Wendler House on South Main Street, the center part of the Phillip Manor House, and the old Ferdinand Herff house on Herff Road. William Dietert built a dam to power a cypress sawmill and gristmill at the present dam site in Boerne. A post office, stagecoach stop, blacksmith shop, livery stable, and schoolhouse were opened.

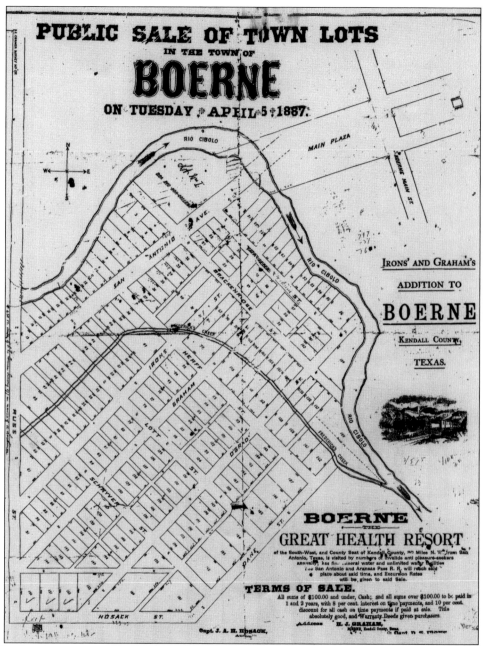

The San Antonio and Aransas Pass (SA&AP) Railroad required towns to pay for railroad rights-of-way and depots for rail stops. This triggered the sale of a large tract of land to the west of the Cibolo to raise money for railroad service. The sale began on April 5, 1887. The advertisement above shows the first major housing development in Boerne, Iron's and Graham's Addition, the "Flats." A prospective buyer could purchase land for a home in this "Great Health Resort" for $100. For many years, "coloreds" were permitted to buy land only in the Flats. Now the Flats is a neighborhood of many cultural backgrounds, many old families, and many new ones. The two maps create a graphic example of how transportation plans and marketing influence population growth and development.

George Kendall apprenticed with Horace Greeley and established the *New Orleans Picayune* in 1834. He served with the Texas Rangers in the Mexican War, was imprisoned in Mexico, and became a famous war correspondent. In 1856, he started sheep ranching near Boerne at his beloved Post Oak Spring Ranch, introducing the merino and rambouillet breeds, sheep dip, and a unique approach to dealing with predators. Rather than the common practice of hiring hunters to kill off the predators, he hired expert herders to tend his 2,000 ewes. In 1858, his herd produced a record 9,000 pounds of wool. Herders were more concerned about hostile Native Americans, so they carried double-barreled shotguns, Bowie knives, and Colt six-shooters. Kendall led the petition drive to form a new county and organized local defenses against marauders. Kendall County was named after him in 1862.

William Dietert established the sawmill and gristmill on the bank of the Cibolo at the present dam site. The first use of the mill was for making boards from the bald cypress trees that grew along the creeks and rivers. Most of the cypresses in the area were taken; today's cypresses are rarely more than 150 years old.

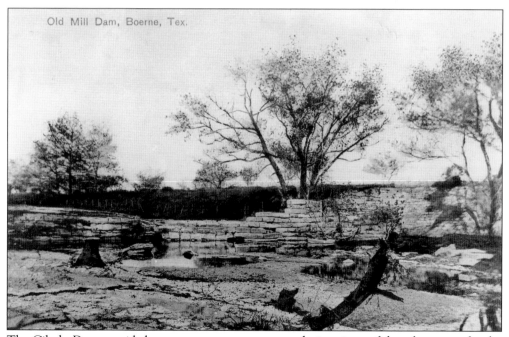

The Cibolo Dam provided a more secure water source during times of drought, power for the mills, and a park-like area with a swimming hole. River Road creekside was always a popular place, especially for the well-fed ducks, but much of it remained in private ownership for years.

On an early morning in 1871, Clint and Jeff Smith went to herd their father's sheep along Cibolo Creek and suddenly fell into the hands of Lipan Apache and Comanche warriors. Clint lived with Comanches for five years, until he gave himself up in a trade for Native American prisoners at Fort Sill. Jeff was bought by Apache chief Geronimo, captured by bandits, and returned in 1878 for a $1,000 reward. The brothers were quite "Indianized" when they returned and always into some kind of mischief. Years later, Clint wrote, "We two boys were pretty wild at first . . . and did not fit very well in polite society." A neighbor actually found them roasting his cow that they had killed with their father's gun. Their father took them to see Geronimo when he was a captive himself in San Antonio at Fort Sam Houston. The old man recognized Clint, and they talked for a long time. A subdued and "Christianized" Geronimo wound up at the St. Louis World's Fair in 1904 selling pictures of himself for 25¢ to delighted tourists.

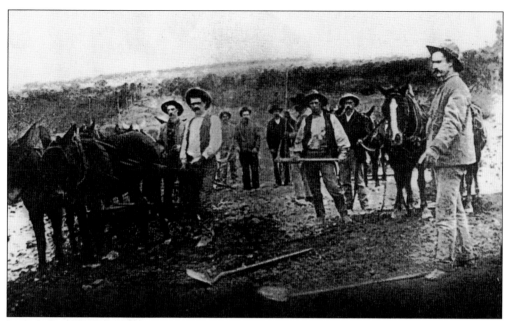

Included in the list of offenses for which local folks could be jailed were "lunacy" and "failure to work roads." Able-bodied men were expected to participate in roadwork. After 1900, a man could be exempted from roadwork through membership in the volunteer fire department. Failure to respond to one fire alarm would result in losing one's position with the fire department, and then it was back to roadwork.

The Hill Country is riddled with caves in the honeycombed limestone underworld. The photograph above is thought to be of a moonshiner gathering at a cave in the Spring Creek area. In modern times, the Texas Speleological Association, the Texas Speleological Survey, and the Texas Cave Management Association help private landowners protect their caves from trespassers with education and protective gates. (Courtesy Sonny Davis.)

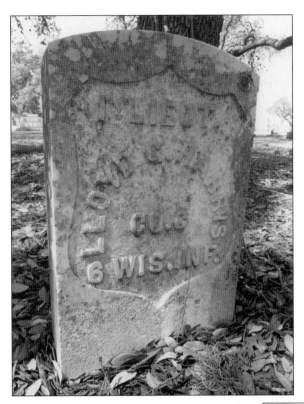

A small headstone in the Boerne Cemetery notes that 1st Lt. Loyd Harris served in the Union army as an officer in Company C of the 6th Wisconsin Infantry. His daughter Florence married John Herff, and they built a home on the Cibolo in Boerne called Suitsus, meaning "it suits us." Harris's letters and photograph collection are archived in Wisconsin. (Courtesy Juanita Chipman.)

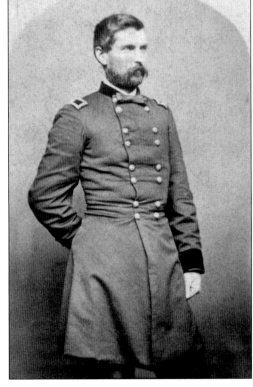

Loyd Harris went to war at an early age. He saw service at the battles of Fredericksburg and Antietam and led a charge and was wounded at Gettysburg. He also was a member of the Iron Brigade. Through three years of the Civil War, he carried his cherished violin with him. Wounded twice, Harris survived the war and lived to marry and raise a family.

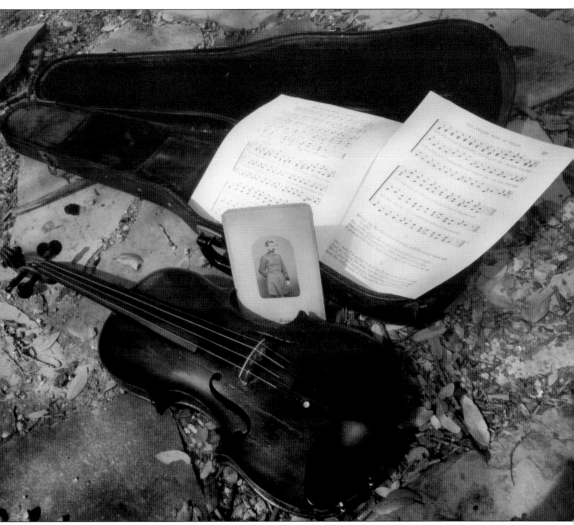

This is the violin that accompanied Harris throughout the war. In the violin case was a copy of the original 1858 sheet music and lyrics to "The Yellow Rose of Texas": "There's a yellow rose in Texas that I am going to see, / No other darky knows her, no darkey only me; / She cried so when I left her, it like to broke my heart, / And if I ever find her we never more will part. / She's the sweetest rose of color this darkey ever knew, / Her eyes are bright as diamonds, they sparkle like the dew, / You may talk about your dearest May, and sing of Rosa Lee, / But the yellow rose of Texas beats the belles of Tennessee." Emily West Morgan was the Yellow Rose, a 20 year-old mulatto indentured servant captured by Santa Anna. Legend has it that her trickery helped cause his defeat at San Jacinto. Her runaway slave boyfriend, B. K., wrote the song. San Antonio's Emily Morgan Hotel bears her name. (Photograph by Brent Evans.)

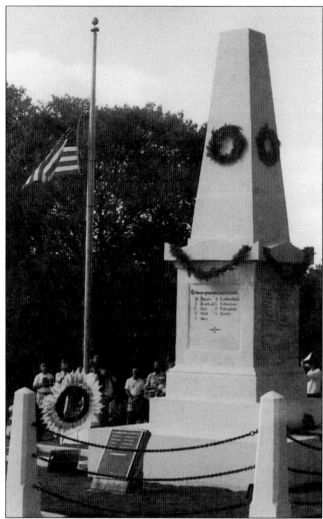

The Treue der Union monument in Comfort (left) marks the common grave of German Union sympathizers. On August 10, 1862, sixty-five men who voted "not to bear arms against the Federal Government" and headed for Mexico were overtaken by 94 Confederate cavalrymen at the Nueces River. The Confederates surprised and killed many and later executed the wounded and captured men. Witness John William Sansom wrote, "the wounded were not given the treatment which civilized people the world over accord willingly to a prisoner of war." In 1865, the bones of these "martyrs to their convictions" were buried at the Treue der Union Monument, one of the few monuments in the South that honors Union losses. The Robert E. Lee House, pictured below in 1918, hosted Lee when he was traveling between San Antonio and Fort Mason. (Left, photograph by Frankie Davis Glenn, courtesy Dicy Glenn Ormiston.)

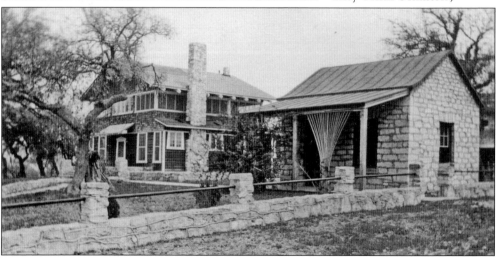

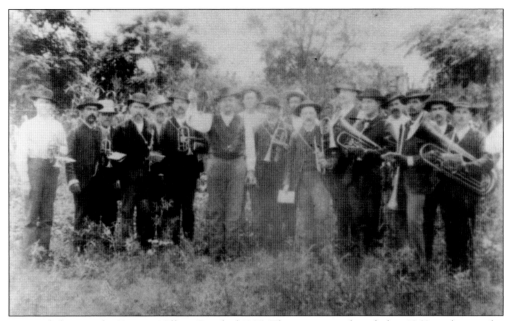

Pictured above is the Boerne Village Band of 1885. The group was founded in 1860, making it the oldest continuously active German band outside of Germany. Accordion player Karl Dienger, one of the town's first schoolteachers, founded both the Boerne Gesang Verein (Singing Society) and the Boerne Village Band. The bylaws must have been loosely enforced: "Any member becoming intoxicated while on an engagement will be expelled."

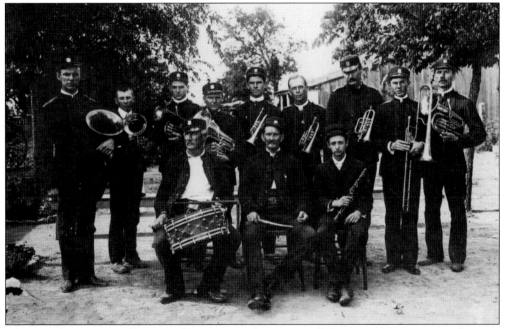

Above is the Boerne Village Band in 1902. In the Texas Hill Country, German oompah music was the only music available for celebrations. In 1991, the first series of "Abendkonzerte" concerts began. In 1994, the band made a concert tour of Germany, and it has received any honors and recognitions. They also play at the Boerne White Sox Vintage baseball games.

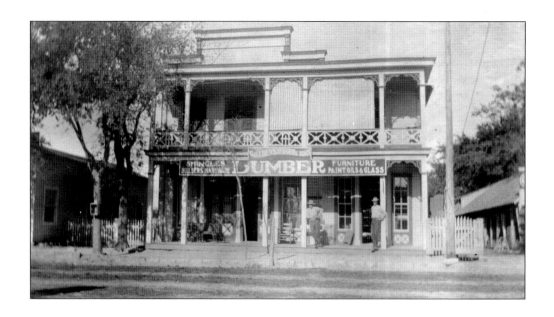

In the late 1800s, Charles Oscar Ebensberger arrived from Prussia and started a hardware and lumber business. He found a demand for funeral coffins, so he added undertaking to his skill set, running the business until 1907. His son, Edmund Walter Ebensberger, became a licensed funeral director and continued the lumber business. In 1957, Edmund's son George Ebensberger took over, and then in 1976, George "Sonny" Ebensberger took the reins, making it the oldest continuous business in Boerne.

## ✢FURNITURE✦

# C. O. EBENSBERGER

### UNDERTAKER

And Dealer in all kinds of

# Lumber ⚜ Cedar ⚜ Timber

### A General Assortment of Furniture.

Bedsteads from $2.75 to $14.00.   Chairs from 65 cts.   Mattresses from $3.   Bedroom Sets from $22.00.   Clear Pine Lumber from $22.00 to $25.00.

## MAIN STREET . . . BOERNE, TEX.

Andy Jackson Potter was born in 1830 and started out racing horses and playing cards. He was a scout, nurse, and ox-team driver. Potter served the Confederacy and was later an Native American fighter. In Boerne, he drove a freight wagon for the SA&AP. In 1880, when he was a circuit-riding preacher, Potter dropped dead in the pulpit mid-sermon and was buried in Walnut Creek Cemetery. (Courtesy Sonny Davis.)

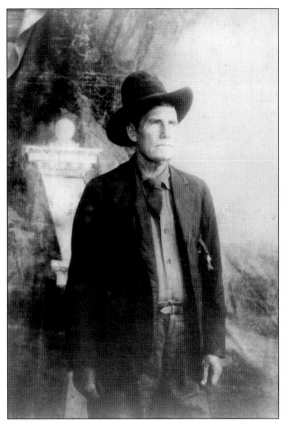

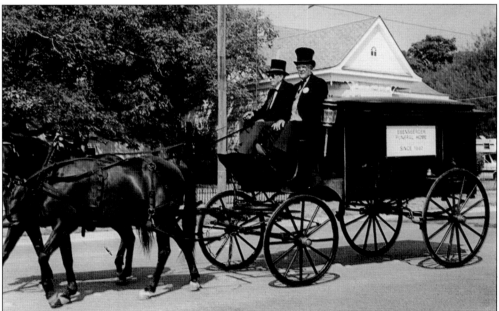

The horse-drawn hearse was rented from the Schrader Livery. It would also double as an ambulance in times of need. The first motorized hearse went to work in Boerne in 1920. Above, the Ebensbergers liven up a parade in 1970 with a historic horse-drawn hearse.

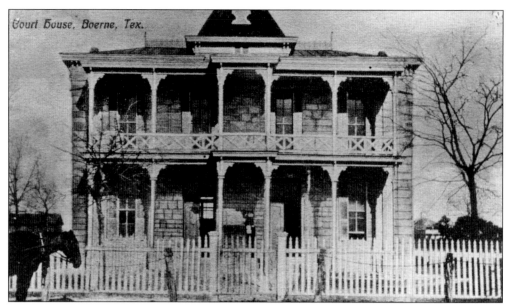

In 1862, Kendall County was organized, taking parts from Bexar, Comal, Blanco, and Kerr Counties. The original courthouse was built in 1870 with limestone blocks quarried locally. Surveyor John James donated the property. The courthouse was expanded in 1909, renovated in 1945 and again in 1999, and restored and rededicated in 2010, with help from the Texas Historical Commission. The Kendall County Courthouse is the second-oldest functioning courthouse in Texas.

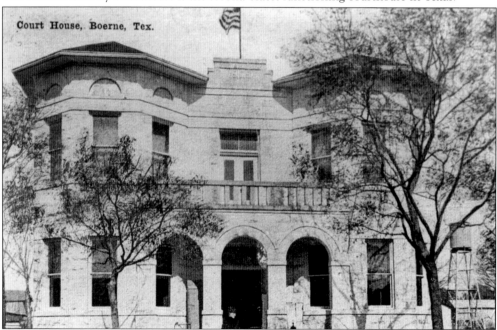

When the Kendall County Courthouse was expanded in 1909, doubling its size, the familiar front was added. Alfred Giles was the architect. To the east of the courthouse stands the old county jail, built around 1884. Most likely, there were makeshift temporary holding facilities before this, but records do not identify where. The most common offense for being locked up was theft of livestock or farming equipment.

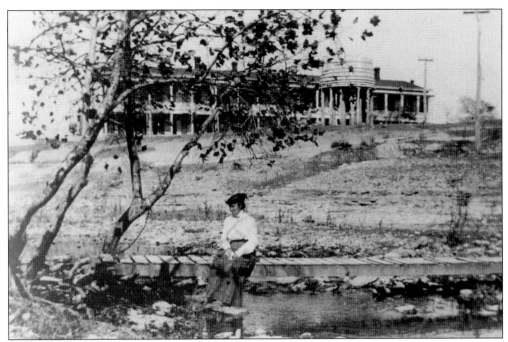

In 1859, John James sold a parcel of land on the Cibolo to Erastus and Sarah Reed for $200, and they built a home in the Southern Colonial style. Since then, the property has changed hands several times and expanded into a stagecoach stop and wagon yard before becoming the Boerne Hotel. The above photograph is from the west side of Cibolo Creek in 1890. In 1909, Dr. H. J. Barnitz bought the property and changed the name to Ye Kendall Inn. It changed ownership numerous times and has been a hotel, restaurant, and place for special community events. In 1982, Ed and Vicki Schleyer restored it and opened Victoria's restaurant. The restaurant is now the acclaimed Limestone Grill, and the state-of-the-art inn facilities include a wide variety of suites, rooms, cabins, and a banquet hall that can accommodate up to 400 people. It is now owned and operated by Ed and Elisa McClure and Dr. Peter Leininger.

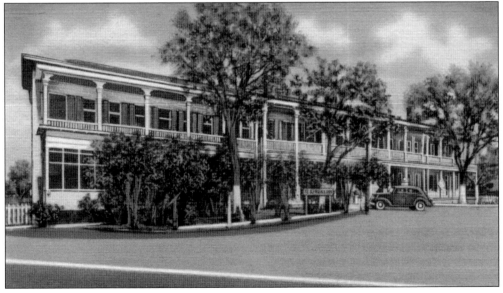

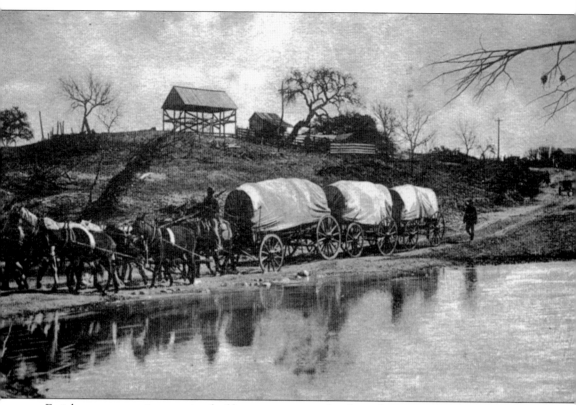

Freight transportation consisted of brave teamsters who drove horses, mules, or oxen pulling multiple covered wagons. These teamsters often traveled at great peril along routes through areas with named landmarks such as the Krempkau Divide, Spanish Pass, Ammann Crossing, Turkey Knob, Seven Sisters, Mount Rigi, Jungfrau, and Malakopf. (Courtesy Paul Barwick.)

*Two*

# ROUTES, RAILS, AND ROADS

## BY PAUL BARWICK

Travel routes through Boerne and the Texas Hill Country developed in response to topography and water availability. The Balcones Escarpment, a semiarid ecoregion of Texas, is a geologic uplift full of rolling hillsides, valleys and canyons created by rivers, and creeks and drainages eroding the limestone landscape.

For centuries, wildlife, prehistoric peoples, Native Americans, Spanish explorers, Mexicans, and European immigrants followed pathways through the wilderness seeking water, food, mineral resources, and places of habitation in the moderate climate of South Central Texas.

The evolution of cultural migration and immigration is evident in the names of regional routes such as Camino Viejo, Camino Pinta, Upper Military Road, Boerne Stage Road, Upper Immigrant Route, San Saba Road, Old San Antonio Road, Old Fredericksburg Road, Old Spanish Trail, State Highway 9, U.S. Route 87, and Interstate Highway 10.

From its humble beginnings in 1849, Boerne can attribute its greatest period of growth to the transportation revolution of railroads. This quiet farming town blossomed in the spring of 1887 with the arrival of the SA&AP. An extensive road network has been built over the following decades; however, this pales in comparison to the almost overnight explosion of tourism, commerce, and health facilities that developed in the late 19th century.

—Paul Barwick

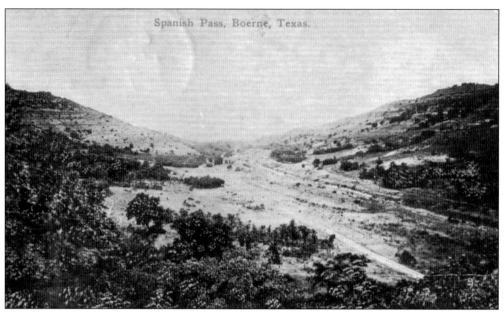

Spanish Pass, Boerne, Texas.

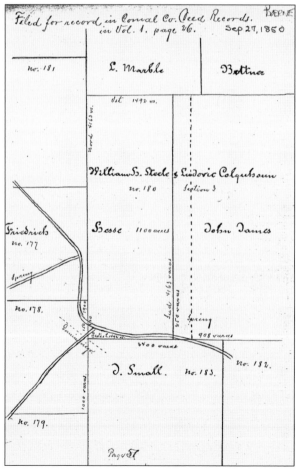

Spanish Pass is a natural pathway between the San Antonio and Guadalupe River Basins. This is where the Camino Viejo, the Old Road, an ancient Paleoamerican and Native American trail, led from San Pedro Springs in San Antonio and linked to locations such as Fredericksburg, San Saba, and beyond.

The Camino Viejo is clearly marked in the northwest corner of the John Small survey shown on this sketch filed in Comal County records office in 1850. This location would soon be the site of the beginnings of present-day Boerne.

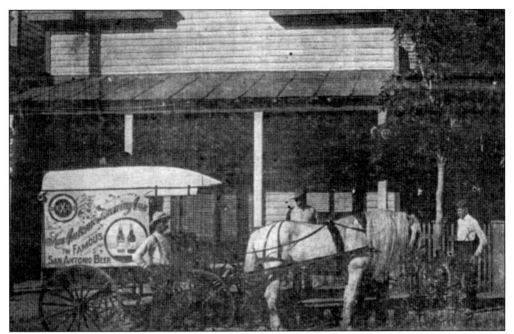

The San Antonio Brewing Association, later Pearl Brewery, delivered beer to local bars and hotels throughout Boerne. It was brought by train to the Boerne depot at a tin-clad icehouse. Art and Emil Schwethelm delivered beer to the Billy Vanderstratten Saloon on Main Street; it was destroyed by fire in 1908. The old gray horse was a fixture on Boerne Streets.

Thousands of acres of farmland were part in the cotton industry beginning in the 1880s. By the 1920s, feed crops were more profitable, and tenant farming became popular as the Great Depression took hold. The sinking economy took family farms and ranches, and many men had to leave the Hill Country in search of work.

By 1901, there were three variations of horseless carriages sputtering and frightening horses on Main Street in Boerne. Three prominent Boerne merchant families—the Zieglers, Schertzes, and Kuhlmanns—owned these early automobiles. In the photograph, all the carriages keep

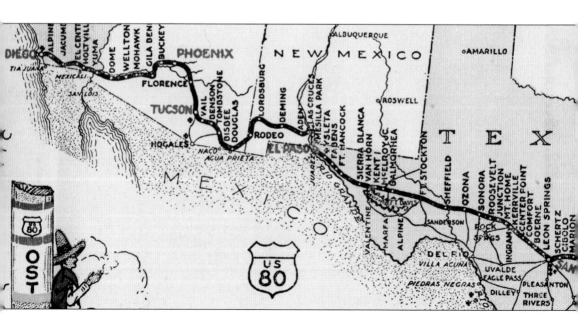

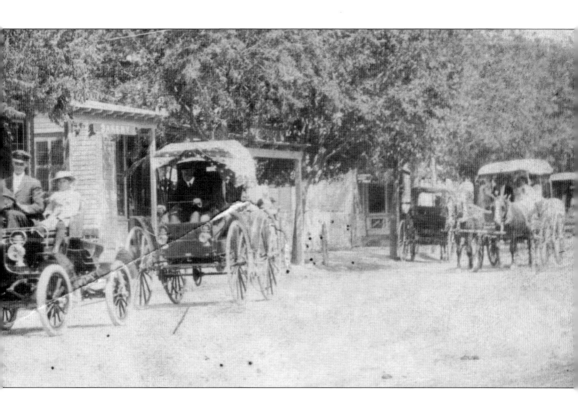

a safe distance from this trio of mechanized transportation. Horses would tend to shy from the noisy contraptions. Native hackberry trees were planted along Main Street for shade and hitching posts.

OLD SPANISH TRAIL
SOUTHERN BORDERLAND TRUNKLINE

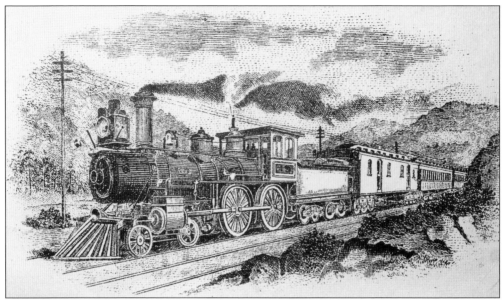

This engraving was on an auction poster; it is of a 4-4-0 American-type steam locomotive, which was representative of the engine roster of the SA&AP during the early years of the railroad company. Telegraph poles alongside the tracks were typically made from heart cedar harvested in the canyons of the hill country.

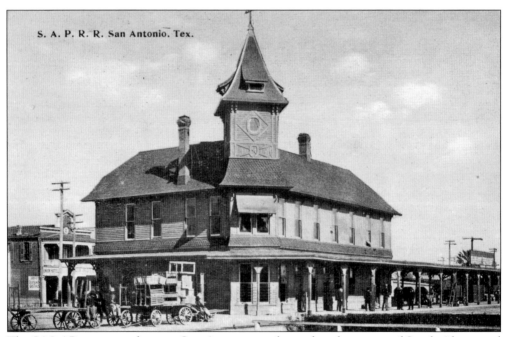

S. A. P. R. R. San Antonio. Tex.

The SA&AP passenger depot in San Antonio was located at the corner of South Alamo and South Flores Streets. This was the connection point for the Kerrville Branch to the SA&AP and all other rail connections throughout the state. It was at this depot that Teddy Roosevelt, lieutenant colonel of the 1st U.S. Volunteer Cavalry, loaded up his Rough Riders for Florida and their embarkation to Cuba.

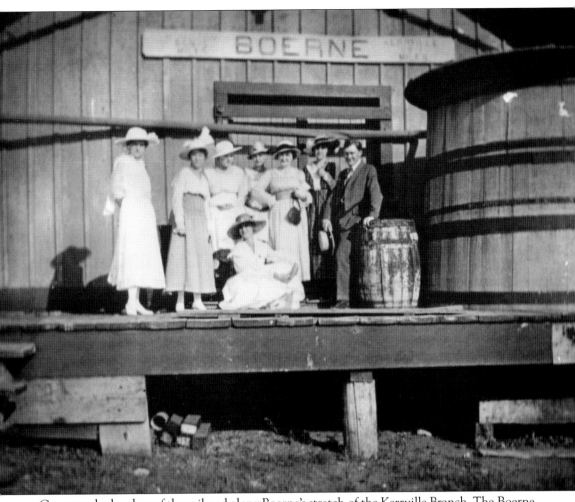

Gone are the heydays of the railroad along Boerne's stretch of the Kerrville Branch. The Boerne depot was a gathering place for visiting with family, friends, and neighbors. A cypress tank is for capturing rainwater, as there was not an elevated water tank at the depot. Rainwater harvesting and rail travel made good sense 100 years ago—and still do.

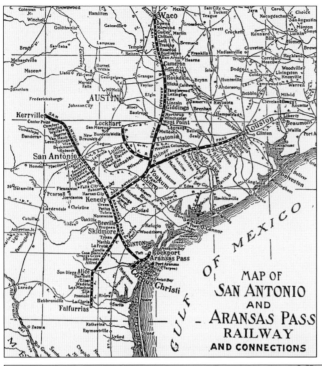

Map of San Antonio and Aransas Pass Railway and Connections

The SA&AP totaled over 880 miles of track connecting San Antonio, Corpus Christi, Houston, and Waco. The line to Corpus Christi was completed in 1886. By early 1889, the SA&AP completed the line to Houston, which was followed by a line into Waco two years later.

Railroads were the driving force for the establishment of standard time. The purpose of this was to create a uniform system of timekeeping to coordinate travel over long distances. Timetables were then published to provide patrons with departure and arrival times for trains. Timetables are read from the top down in the left hand column and from the bottom to the top in the right column.

**Tourist Pullman Sleepers between San Antonio and Yoakum on trains 13-4 and 3-14.**

## SAN ANTONIO AND KERRVILLE

| No. 156 Freight Daily Ex. Sunday See Note | READ DOWN | | Miles | STATIONS | Population | READ UP | | No. 155 Freight. Daily Ex Sunday See Note |
| --- | --- | --- | --- | --- | --- | --- | --- | --- |
| | No. 42 Pass. Daily | No. 44 Pass. Sunday Only | | | | No. 41 Pass. Daily | No. 43 Pass. Sunday Only | |
| 7 30AM | 4 50PM | 8 05AM | 0 | Lv ¶San Antonio . Ar | 96,614 | 9 15AM | 6 40PM | 6 40PM |
| * 8 02 " | * 5 15 " | * 8 40 " | 10 | Ar Robards.... " | 5 | * 8 45 " | * 6 10 " | * 5 55 " |
| * 8 25 " | * 5 30 " | * 8 55 " | 15 | " Olga........ " | 25 | * 8 25 " | * 5 55 " | 5 30 " |
| 8 30 " | * 5 34 " | * 8 58 " | 16 | " Beckman ... " | 25 | * 8 19 " | * 5 52 " | * 5 02 " |
| 8 42 " | 5 42 " | 9 05 " | 19 | " Viva........ " | 5 | 8 11 " | 5 42 " | * 4 50 " |
| 8 55 " | 5 50 " | 9 08 " | 21 | " Leon Springs . " | 75 | 8 08 " | 5 36 " | 4 45 " |
| * 9 00 " | * 5 52 " | * 9 11 " | 22 | " Remount.... " | 0 | * 8 03 " | * 5 28 " | * 4 41 " |
| 9 15 " | 6 03 " | 9 22 " | 25 | " Van Raub... " | 75 | 7 55 " | 5 20 " | 4 30 " |
| 9 45 " | 6 22 " | 9 41 " | 32 | " ¶Boerne.... " | 886 | 7 40 " | 5 03 " | 4 10 " |
| *10 05 " | * 6 37 " | * 9 56 " | ... | " Spanish Pass " | 0 | * 7 28 " | * 4 50 " | * 3 35 " |
| * | * | * | 40 | " Kenilworth . " | 10 | * ........ | * | * |
| 10 20 " | 6 46 " | 10 06 " | 41 | " Welfare.... " | 100 | 7 18 " | 4 40 " | 3 15 " |
| 10 35 " | 6 55 " | 10 16 " | 45 | " Waring..... " | 325 | 7 08 " | 4 30 " | 3 00 " |
| * | * | * | 48 | " Guad'pe River " | 10 | * | * | * |
| 10 59 " | 7 08 " | 10 30 " | ... | " Fred'berg Jc.. " | ...... | 6 56 " | 4 18 " | 2 40 " |
| 11 20 " | 7 17 " | 10 39 " | 52 | " Comfort.... " | 1,000 | 6 48 " | 4 08 " | 2 20 " |
| * | * | * | 56 | " Moores.... " | 5 | * | * | * |
| 11 50AM | 7 35 " | 10 57 " | 60 | " Center Point " | 550 | 6 30 " | 3 50 " | 1 45 " |
| * | * | * | 66 | " Split Rock.. " | 10 | * | * | * |
| * | * | * | 69 | " Parson...... " | 0 | * | * | * |
| 12 20PM | 8 00PM | 11 25AM | 71 | Ar ¶Kerrville....Lv | 1,843 | 6 05AM | 3 25PM | 1 10PM |

(NOTE:—Trains 145 and 146 have Passenger and Baggage Car Attached.

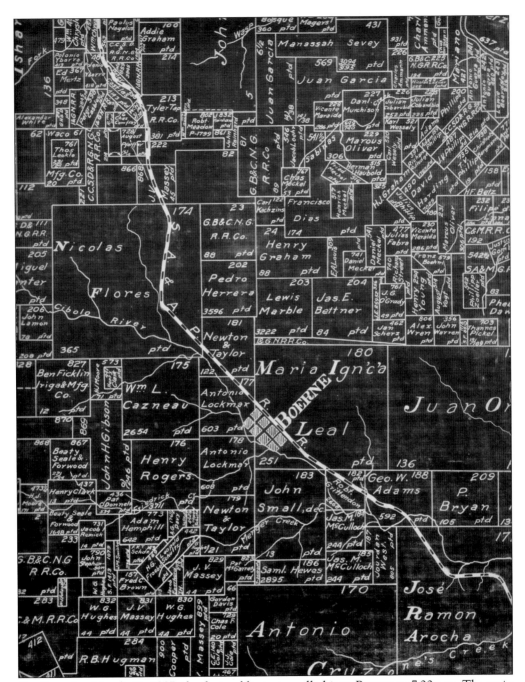

On Saturday, March 12, 1887, the first public train pulled into Boerne at 7:00 p.m. The train consisted of seven red Pullman passenger cars, one baggage car, and two boxcars. It carried over 600 people, and a ticket cost 95¢. The 30-mile journey from San Antonio to Boerne would now only take three hours instead of the typical full day. Once the SA&AP crossed the Kendall County line, the railroad crossed the Cibolo River, running parallel to it for several miles and then turning due north up Spanish Pass towards Waring.

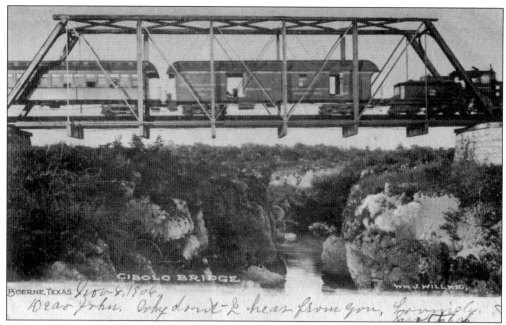

CIBOLO BRIDGE.

BOERNE, TEXAS *Nov 8, 1906,*
*Dear John, Why don't I hear from you, Lovingly,*

WM. J. WILLKE.

The original wooden bridge that spanned Cibolo Creek below Herff Falls was a Howe through truss design. This span offered a spectacular view of the deeply incised 110-million-year-old rudist reef formation of the Cibolo Creek below. Two limestone abutments supported the bridge. In this image, a passenger train and one baggage car pulled by SA&AP steam locomotive no. 2, *Aransas Pass*, cross Cibolo Creek headed for San Antonio.

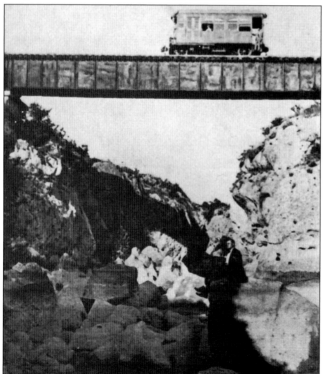

The earlier wooden bridge was replaced with a steel girder bridge to accommodate heavier locomotives and freight loads. However, on this day, a gas-powered bus, No. 500, pauses atop Cibolo Creek long enough for the picture. A man is sitting on a rock at the base of the canyon.

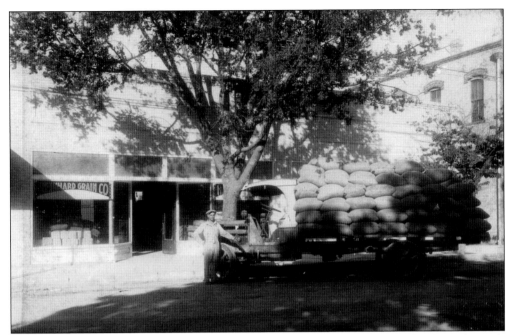

The first flatbed truck for commercial use in Boerne was owned by Charles Reinhard Sr. This early truck, without doors or windshield, was used to transport grain threshed and bagged in the field to be loaded onto boxcars at the railroad depot for delivery to nearby roller mills for processing. Standing by the truck is Harry Shrader, who later died when his small plane crashed.

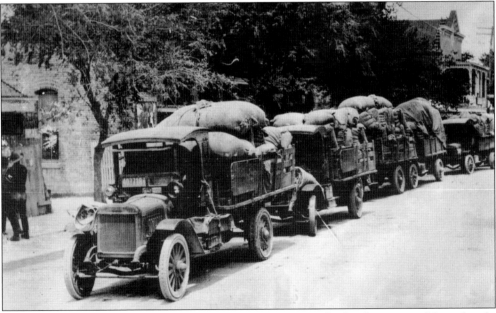

As roadways developed, fleets of trucks began infringing upon the freight service of the railroads. Convoys of trucks were used for hauling freight throughout the region, and they were not restricted to limited schedules and railroad lines. This convoy of trucks on Main Street in Boerne is loaded with wool and mohair, long a commodity of the sheep and goat industry developed and promoted by the namesake of Kendall County, George Wilkins Kendall.

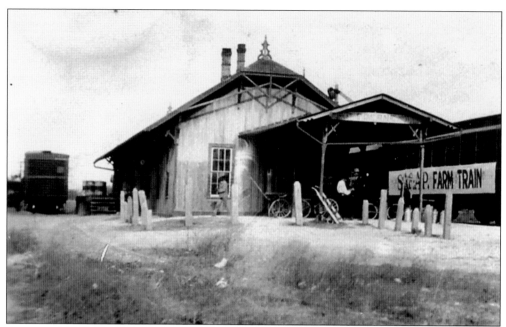

A successful business strategy employed by the railroads was the promotional farm train, which would travel rural rails pulling boxcars and flatcars loaded with the latest in farming and ranching equipment and supplies. On hand were the latest seed varieties, farming equipment, and current information on agricultural practices and opportunities in the region.

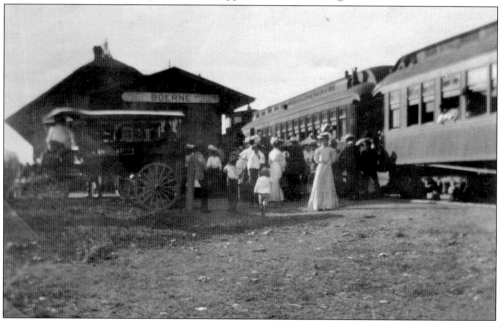

Many health seekers suffering from tuberculosis journeyed to Boerne for the restorative powers of fresh air, low humidity, invigorating ozone, and sparkling springwaters. Jimmie Rodgers, known as the "Blue Yodeler" and "Father of Country Western Music," often rode the train through Boerne, headed for his Hill Country residence in Kerrville where he could get temporary relief from his chronic battle with tuberculosis.

Railroad depots were one of the primary hubs of cultural activity for most communities. Consequently, they reflected societal customs of the day. This was true with racial segregation. Depots and other public places had separate waiting rooms, dining rooms, ticket booths, restrooms, and drinking fountains for white and black patrons.

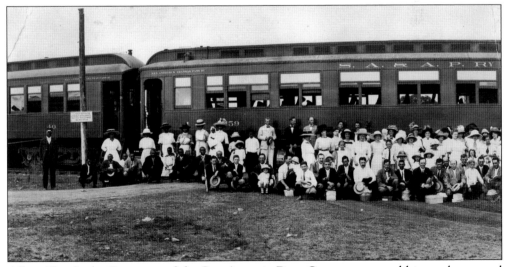

Albert Kronkosky Sr., owner of the San Antonio Drug Company, treated his employees and families to a train excursion and picnic at his weekend home atop Kronkosky Hill in Boerne. Even off the train and on the grounds of the Boerne depot, it is obvious that segregation was embedded in the culture. (Courtesy Boerne Benedictine Sisters.)

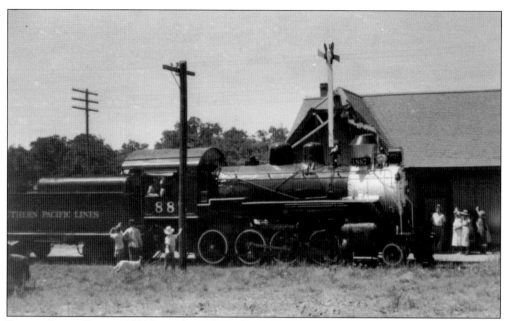

Boerne Surrey Days in 1950 hosted a rail trip from San Antonio to Boerne. Children were given small bags of imitation coins and told to hold tight to their money. When the train stopped at Viva, the present-day entrance of Dominion, to take on water from a water tower, a band of masked gunmen (actors) rode up on horses, boarded the train, and proceeded to rob the surprised children of their loot and gallop off into the surrounding hills.

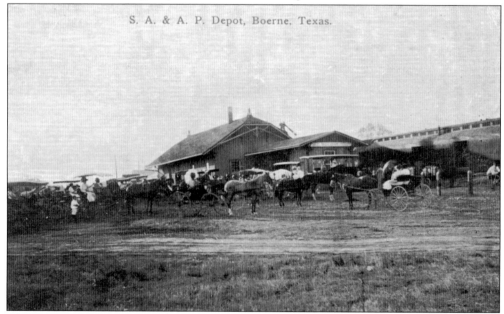

All varieties of conveyances converged on the Boerne depot when the scheduled passenger train was due to arrive. This menagerie of wagons was employed to bring the throngs of visitors, patients, and residents from the depot to downtown, typically rolling down Depot Street, later renamed Rosewood Avenue because of the rather unsavory reputation of the variety of people who drifted into town.

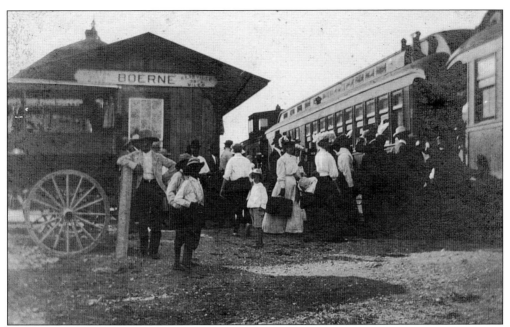

Travelers line up to board the wooden passenger cars headed for San Antonio. To the left is a typical ambulance that transported patrons to and from the depot. At the faint sound of a steam whistle, young boys would head for the depot so they could work for a few tips by handling baggage. The depot sign notes the rail distances to Kerrville and Houston.

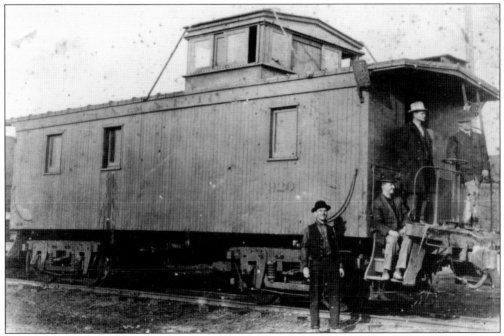

Early cabooses were spacious wooden constructions. This is where brakemen would be stationed as they manually assisted with braking the train and watching for any hazardous conditions along the track or up ahead by looking through the small cupola on top. Railroad company officials also rode in the caboose of freight trains to observe operations and travel to meet business associates.

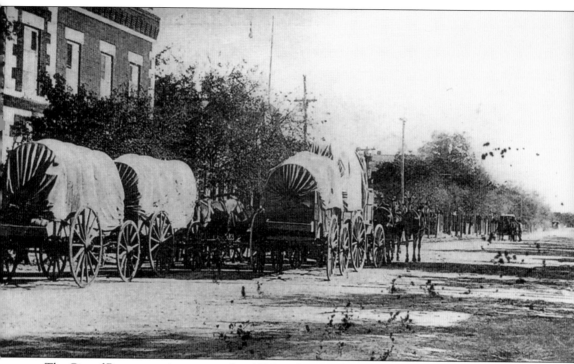

The City of Boerne was incorporated in 1909, with a population of 885. William John Wilke was the first mayor. As Boerne grew, the need for goods and services increased. Pictured above are covered wagons next to the William Ziegler Building in 1910.

# Three

# TURN OF THE CENTURY

In 1890, the *Boerne Post* replaced the *Register* as the town newspaper. Max Beseler opened his bar on Main Street, and the Ort Bakery and Saloon were established. In 1894, master cabinet- and furniture maker A. S. Toepperwein built his home. And in 1898, the Schrader brothers bought the old Livery Stable and later converted it to a garage when the age of automobiles arrived.

Boerne's health spa era was in full swing after the railroad arrived. By 1897, the patient population in Boerne was 731, while citizens numbered about 700. Many locals were unhappy with the influx of sick visitors, and the local economy was having mixed returns. While some patients paid their way, some could not. A number of sanitariums operated in Boerne, including the St. Mary's Sanitarium, the Diamond Hospital, Wrights Hill Top Sanitarium, the Lex Sanitarium, and others.

Boerne's 50th anniversary was celebrated with pomp and pride. There were a reception, street decorations, school activities, historical observances, music, balls, and the inevitable Main Street Boerne parade.

The 20th century ushered in lots of activity. The Business Mens' Association formed the Boerne Chamber of Commerce. The Boerne White Sox baseball team was formed. H. O. Adler opened his store; the Boerne Turn Verein was organized, and the Boerne Masonic Lodge was established. At this time, electricity was introduced. By 1906, livery stables were all converting to gas stations, and the *Boerne Star* became the town newspaper. The first Kendall County Fair was held in 1905.

Agriculture dominated the local economy. Cattle, sheep, and goat ranching were widespread, and thousands of acres were in cotton production. Fires destroyed a number of buildings in 1908, and some of the stone buildings on Main Street were built to replace those lost to the flames. In 1910, the first telephone operator station was installed upstairs in the Carstanjen Building.

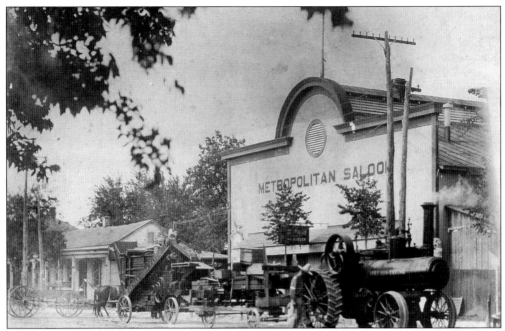

The Metropolitan Opera House and Saloon was the cultural hub of the town, offering theatrical performances, concerts, wedding receptions, dances, funeral gatherings, and beauty contests. This 1901 photograph shows Charlie Schwarz's steam tractor and farm equipment out front. It was the setting for the first county fair in 1905.

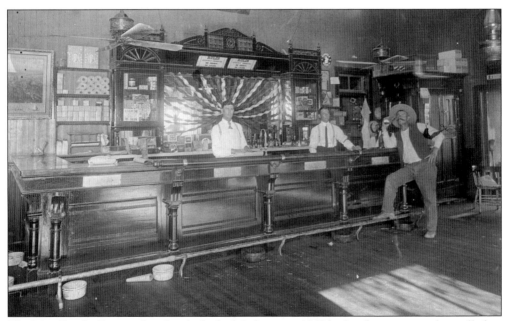

The Max Beseler Bar was handcrafted of solid cherry in 1869 by local artisans, and installed in 1889. It served alcohol for 50 years, then shifted to ice cream during Prohibition. Prohibition did not last, but the bar did. It eventually landed in the Antlers Restaurant in the Dienger Building. It currently lives upstairs at the Frost Bank in Boerne.

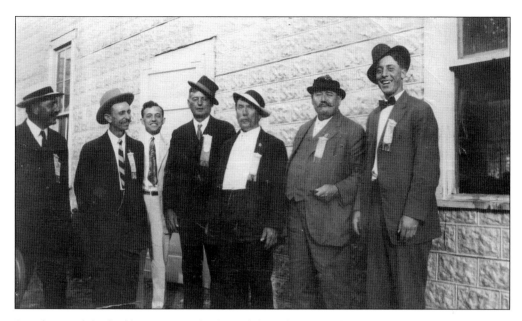

Seen here with his buddies, Max Beseler (far right) was known for his congeniality. His grandparents, Carl and Auguste Beseler, had sailed for America in 1848 and settled in Sisterdale. Their son Ernst lost his life at the Nueces Massacre. Their son Carl served with Union forces in the Civil War and survived to marry Minna and raise four sons, including Maximillian. Max first worked for the railroad and then built the Metropolitan Opera House and Saloon. He later operated a saloon at the Shooting Club, during the time that Camp Stanley did not allow alcoholic beverages to be sold within a 10-mile radius. Below an unknown gentleman pauses while changing a tire. Passing horse-drawn folks would holler, "Get a horse!"

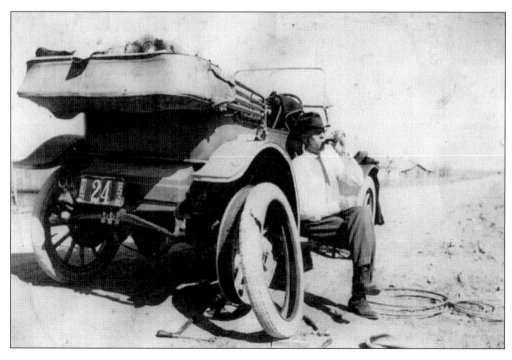

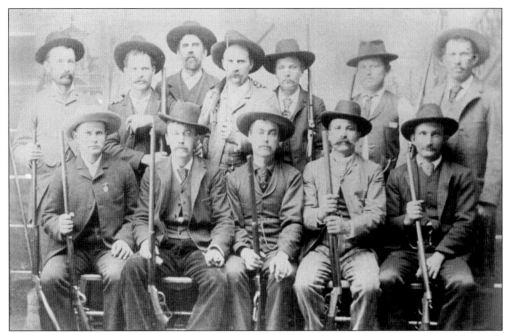

In 1864, the Schuetzen Verein located its range just off North Main Street. The men would show off their shooting skills while the wives cooked meals and the children played. The above photograph was taken in 1891. The Verein moved on to Phillip Manor and other locations, but safety concerns in 1913 prompted the purchase of Shooting Club Road property, where a range, clubhouse, dance hall, and barbecue pit still operate.

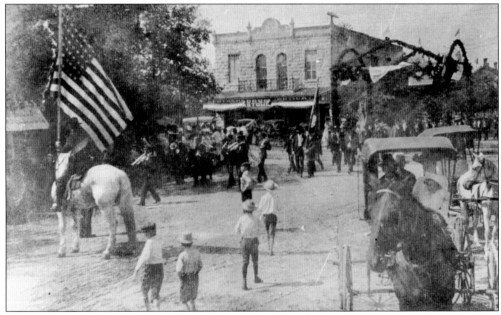

In 1901, the Fourth of July was celebrated in Boerne with, of course, a parade. In 1906, this picture was taken of the Fourth of July celebration. With the Carstanjen Building in the background, the procession turned up San Antonio Street and headed for the Metropolitan Saloon and Opera House. Boerne's tradition of hometown parades continues to this day.

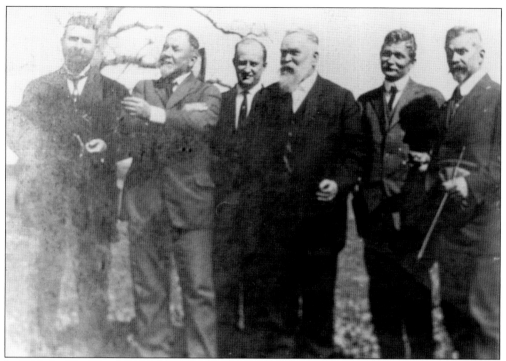

In 1913, the Herff brothers donated 40 acres to the newly formed Kendall County Fair Association, whose purpose was educational, to encourage and develop farming and ranching skills. The fair's goal was to display the best agricultural products and livestock in Kendall County. Pictured from left to right are Adolph, Charles, John, Ferdinand, August, and Willie Herff. The fair association continues to depend on community support to maintain the facility.

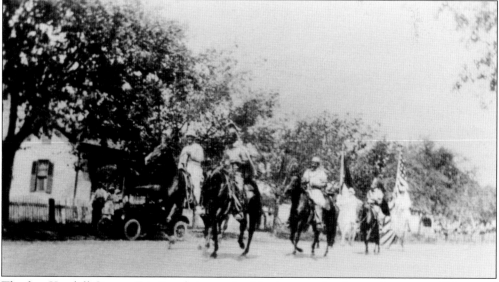

The first Kendall County Fair Parade is seen in this photograph taken at the corner of Main and Lohmann Streets. Boerne has had a long tradition of parades, including the County Fair Parade, the Berges Fest Parade, and the Weinhnachts Parade with Santa Claus. It is a slice of Americana, with candy being thrown to the children in every parade.

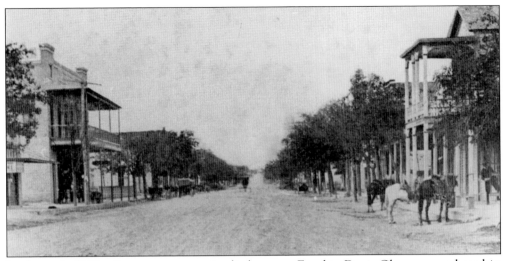

In the early 1900s, Boerne was a quaint little town. Frankie Davis Glenn remembered in *Reminiscences: Stories of a Country Girl*: "Papa worked as a 'cowboy or wrangler' in the year 1900 and he and Mama fell in love. Papa was very handsome, 175 pounds, 6-foot-3-inch, redheaded Scotch-Irish man, who must have thrown a 'wide loop and cut a wide swath' to Mama's way of thinking." (Courtesy Dicy Glenn Ormiston.)

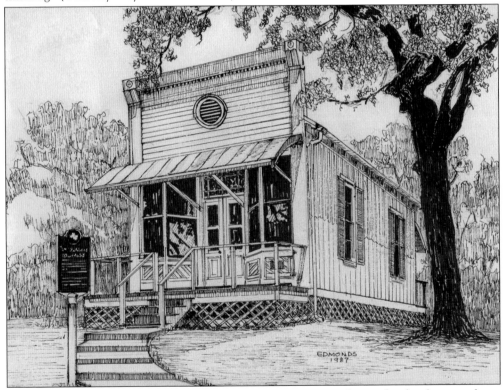

The Henry J. Graham building was built in 1891. It is a two-room house that has been used as a bank, beauty shop, barbershop, offices, and an antique shop. The structure was moved several times. In 1984, Tom and Pat Frost donated the building to the historical society. It was awarded a Texas Historical Subject Marker in 1987 at its present site, behind city hall. (Courtesy Bettie Edmonds.)

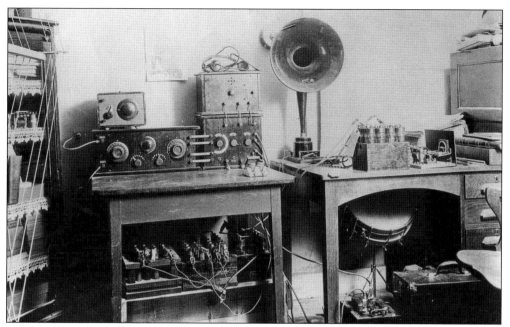

In 1910, Arno C. Richter operated a garage in Boerne and participated in the Gesang Verein (Singing Society). Richter must have liked music and technology, because he owned the first radio in Boerne, seen above. In 1922, the first radio station in San Antonio started broadcasting but lasted only a few months. The second radio station, WCAR, broadcast from 324 North Navarro Street and was later renamed KTSA.

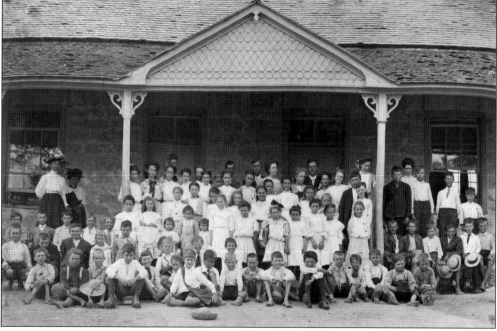

This is the Boerne Public School in 1908. The two-room, limestone-block school building was constructed immediately behind where city hall stands today. A much larger school built in 1911 now serves as city hall.

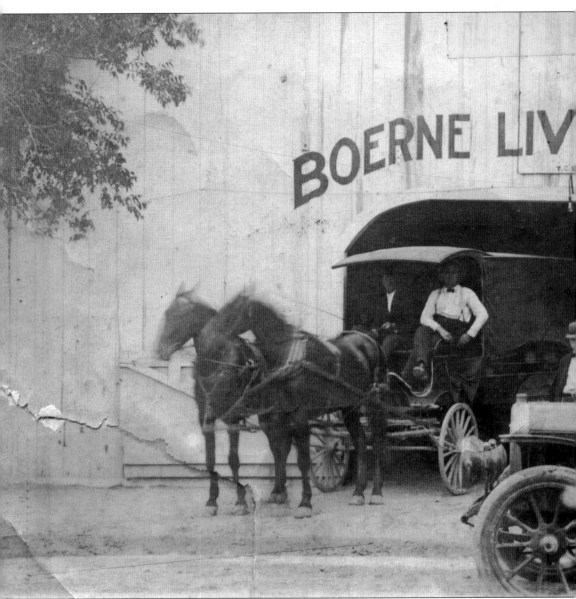

Boerne Livery Stable (seen on the cover of this book) was built by the Schrader brothers in 1898. This may be Boerne's most intriguing photograph, as it captures that brief moment in a time of momentous transition. The automobile transformed life in America and life on Main Street as well. People could travel farther and faster and with more independence. Today, world oil production

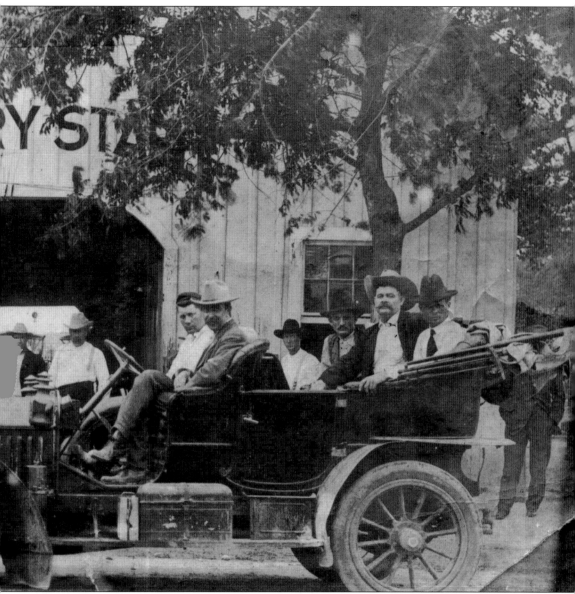

has peaked, environmental problems are mounting, and new transportation technologies and energy sources are being sought. A century from now, what vintage photograph will capture this generation's moment of transition, and what will it be? Some say that the computer is the only modern invention that has been as transformative as the automobile.

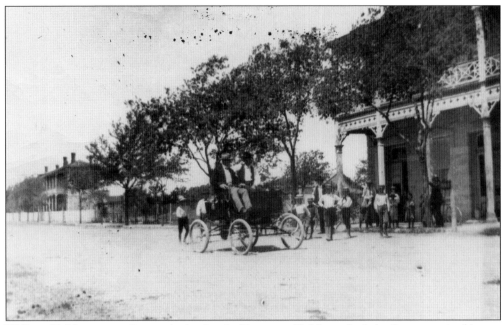

William Kuhlman was always a little ahead of his time. Kuhlman had the first motorized buggy in town in 1905 and also the first telephone, in his drugstore. His business was very successful, and he eventually purchased several large tracts of land in the Boerne area.

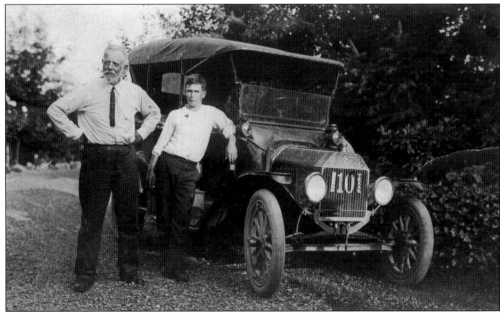

William Kuhlman was born in Germany in 1856, was trained as a pharmacist, and immigrated to Boerne in his early 20s. He opened an apothecary on Main Street that eventually evolved into Roberts Drug Store. He built a home in 1885, returned to Germany and married Marie, his childhood sweetheart, and returned to Boerne. Sadly, Marie and their child died in childbirth. Kuhlman is pictured here with his nephew.

In 1882, Edmund King had leased the Boerne Hotel, now Ye Kendall Inn, and was hunting with a guest. Hunting was usually good just beyond the creek, but the guest's gun accidentally discharged, killing King, who had a wife and eight children. The guest was so remorseful that he funded the lease of nearby ranchlands for Selina King and the children. Selina King purchased the Kuhlman house in 1908.

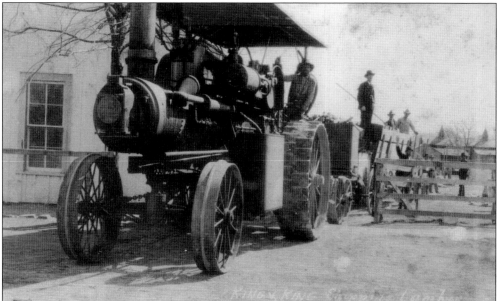

Two of the Kings' sons grew to become prominent businessmen in Boerne, founding King Lumber Company. In the picture above, a steam-operated tractor is being used by workers to move a large load of cedar logs, a common product of the Hill Country.

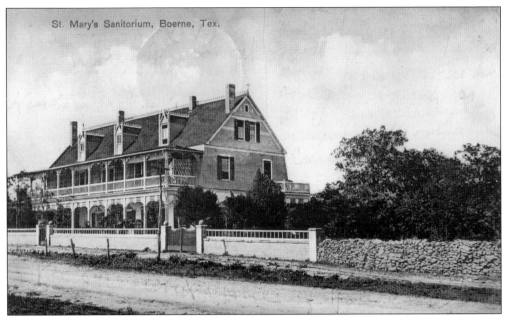

In 1896, the Sisters of Charity of the Incarnate Word purchased property for St. Mary's Sanitarium to assist tuberculosis patients in regaining their health. Dr. Ferdinand Herff had helped found Santa Rosa Hospital in San Antonio as well as this sanitarium as an adjunct facility. Boerne's high, dry climate was considered the best treatment available. This historic reputation of a dry climate should not be forgotten.

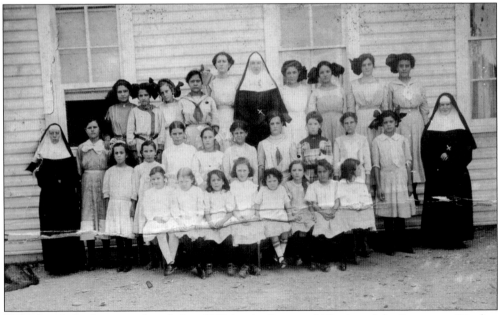

Holy Angel Academy was founded in 1899 by the Sisters of Charity of the Incarnate Word as a select boarding and day school for young ladies and children. The sisters announced it was "situated in the most desirable part of the city and offers every inducement as regards healthful and refined surroundings." Located on North Main Street, the school was "an avenue to offset anti-Catholic bias in public school textbooks."

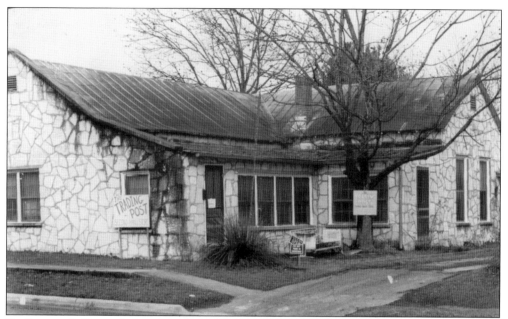

Dr. Diamond's Hospital was originally built as a private residence in 1890. The building led several lives—a general store, a barbershop, a clinic for Dr. John Nooe, and a clinic for Dr. Giggs. Dr. Jack Diamond bought the structure in 1949 and operated the 12-bed facility until 1954. It then became the Trading Post and is now owned and operated by Paula Hayward and Jack Cushman of the Bear Moon Bakery.

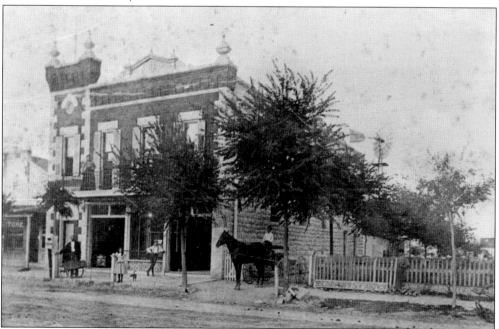

William Ziegler built this ornate structure with upstairs living quarters around 1900. There was a hardware store on the ground floor that also sold windmills. It became Vogt's Hardware Store in 1907. A basement was dug in the back, and an elevator was installed to move goods to the second floor or to the basement. This 1920 image shows a windmill at the rear of the building.

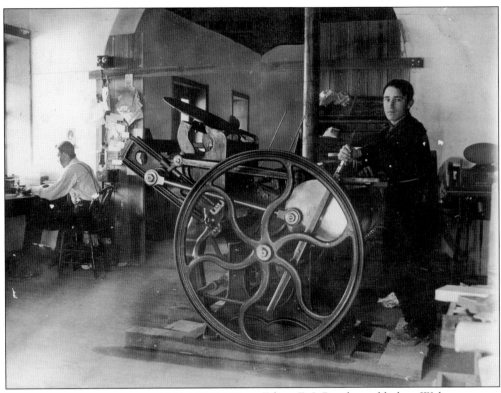

Editor E. J. Brucks and helper Walter Hefner work the *Boerne Star* press in 1906. A vintage letter to the editor showed evidence of a strong baseball rivalry between Boerne and Comfort. A Boerne fan wrote, "The Waring boys were giants!" A Waring fan wrote, "The only reason why Boerne thought the umpire was partial is that it was probably the first time they have ever played according to Official Rules." A newspaper editor would have to be tough. In 1908, William Gammon Davis, a bare-knuckles boxing champion from Limestone County, arrived and purchased the *Boerne Star*. Davis had moved because of "the boll weevil and the dry-county vote in Limestone County." (Both, courtesy Sonny Davis.)

In 1929, Davis sold the paper to his sons, William Gammon Davis Jr. and Jack, and stayed involved with the *Boerne Star* until his death in 1940. Gammon married Ida Lee Martin, and Jack married Irene Purdue. Both wives joined the business. In 1963, a third generation came on board: William Gammon "Sonny" Davis III bought out Jack's interest. Sonny is remembered for his lively storytelling. (Courtesy Sonny Davis.)

Sonny Davis grew up in Boerne and loved his job because he got to know "just about everything that was going on with everybody!" He and his wife, Bennie, sold the paper in 1978 but continued the printing business until 1986. The Davises gave the town its news for 78 years and retired in Moonshine Valley. Sonny Davis is pictured at left with one of the vintage presses. (Courtesy Sonny Davis.)

Albert Kronkosky was born in New Braunfels near the end of the 19th century. His father was successful in the entertainment, wholesale, and manufacturing businesses. In 1911, Albert purchased 27 acres on a prominent, tree-covered hilltop overlooking Boerne, and it became an extravagant entertaining center including walkways with rock walls, pools, gardens, and a tower.

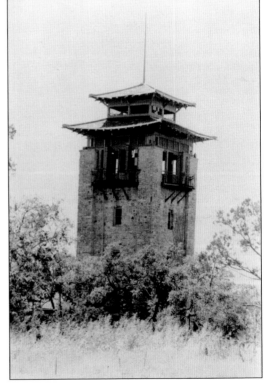

The Kronkosky Tower was built in 1911 around the water storage tank out of native rock with a pagoda-style roof. It hid the generator that supplied half of the electricity for the estate. The other half was provided by the City of Boerne. The Kronkoskys developed flower gardens, water fountains, a dance pavilion, and other creative additions. They entertained many groups, organizations, and members of the community.

The events and parties at The Hill must have been a sight to behold. Being the owner of the Gebhardt Chili Powder Company, Kronkosky had the resources to create a wonderland. The many outdoor features and gathering places made the property a magical experience.

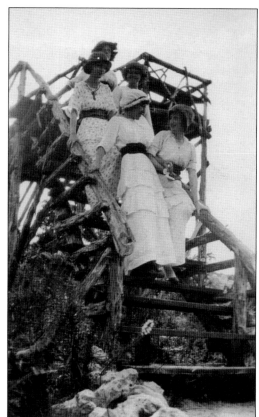

The Kronkosky Bridge was built in the early 1900s to connect the two parcels of the estate, which overlooked the whole town. The Kronkosky family has literally shared the wealth. In 1991, the Albert and Bessie May Kronkosky Charitable Foundation was established, providing the surrounding region with vital philanthropic work ever since.

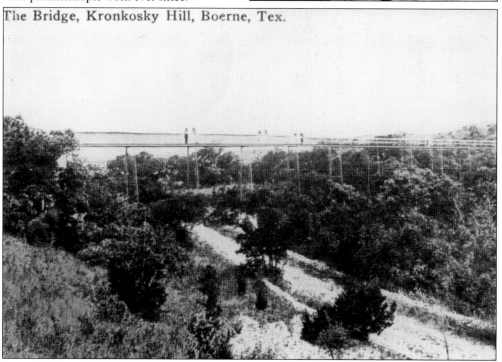

The Bridge, Kronkosky Hill, Boerne, Tex.

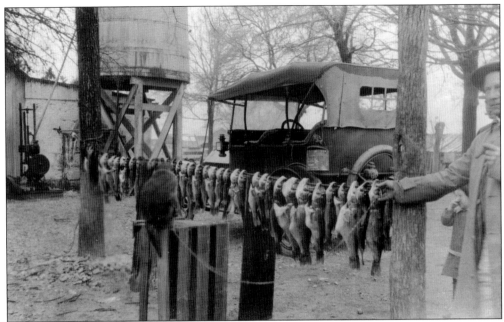

Fishing was good in Kendall County rivers and streams, even within the city limits. Common catches were largemouth bass, Guadalupe bass, bluegill, channel catfish, Rio Grande cichlid, longnose gar, redbreast sunfish, redear sunfish, and crawdads. The little girl appears to be holding her nose.

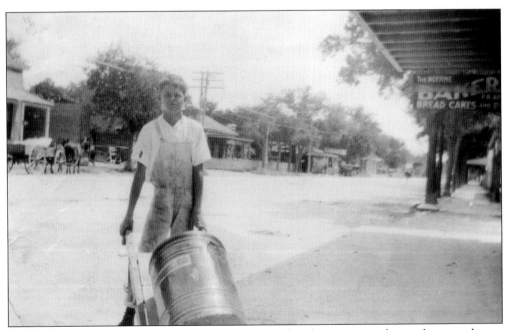

Children often went to work in a family's business, whether the occupation be ranching, medicine, grocery, or baking. Everything changed with the coming of World War I, and the radio played, "How you gonna keep 'em down on the farm, after they see Paris?" The good old days were left behind as fathers and sons marched off to war.

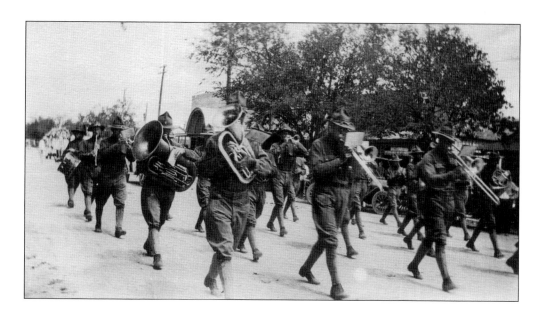

World War I impacted all of America, and Boerne was no exception. Kendall County lost 14 sons, 12 of whom are commemorated on the War Memorial in Veteran's Park across from St. Peter's Catholic Church. Pictured above is the Army Infantry Marching Band in 1916 in a Boerne parade. The war is estimated to have cost 9,721,000 soldiers (on both sides) and 6,821,000 civilians. About 116,000 American servicemen died in the so-called War to End All Wars. Pictured below is the monument that was dedicated to those soldiers by Henry Graham in what is now Veterans' Park. After World War II, the names of nine fallen men from Kendall County were added, and after the Korean War, two more. In 1992, a bronze sculpture by Jay Hester was installed at the top of the stone monument.

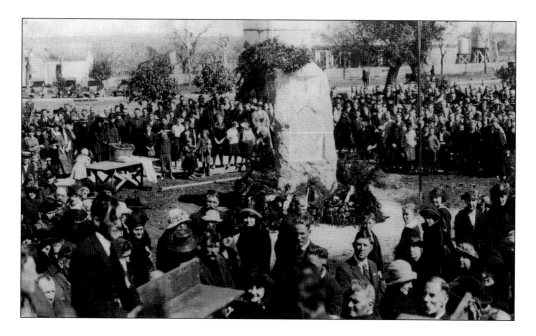

In 1949, the Forty-Niner Club pledged to "guard the heritage of Boerne during the next hundred years . . . and keep alive the spirit of 1849 and to sponsor all things historical." Its brands were displayed in Boerne's centennial celebration brochure. (Courtesy Gavin Walbeck.)

# Four

# SMALL TOWN ERA

In 1924, a Parent-Teachers Association was formed in Boerne. In 1929, the Great Depression began. Automobiles had pretty much replaced the horse and buggy by 1930; and in 1932, St. John's Lutheran Church was built on what is now Rosewood Avenue. The Boerne Utilities Company was formed in 1940, and the new sewage treatment plant was opened. The following year, the Boerne Grange no. 1545 was organized. It was said for many years in Boerne, "If you want to get anything done, talk to the Grange."

The United States entered World War II in 1941, and civilians experienced shortages of goods and rationing during the war. Truck farming was common, with gardens springing up all over town and folks remembering how their parents used to get food from the land. Among locals lost in the war were both Roeder twins.

In 1949, Boerne celebrated its centennial with multiple events. The Centennial Commission marketed the town as the "Key to the Hills," since it would be the first stop for sightseers from San Antonio.

The chamber of commerce boasted "good hunting, good fishing, beautiful scenery, modern schools, healthful climate, relaxation and rest. We have a lot of scenery, a lot of hills and streams and a real friendly-like way of life we want to share with our friends. It is the neighborly thing to do."

In 1952, the Boerne Grange started the Boerne Public Library. As Lady Bird Johnson said, "Perhaps no place in any community is so totally democratic as the town library. The only entrance requirement is interest."

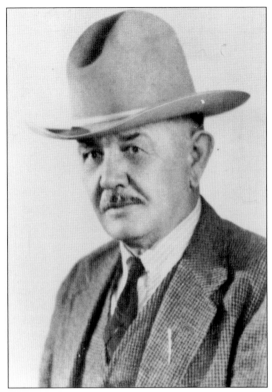

Vaudeville's "Dead Eye Dick" was Adolph "Ad" Toepperwein, who still holds the greatest shooting record of all time. At the old San Antonio Exposition Grounds in 1906, he hit 72,491 out of 72,500 aerial targets (small wood blocks) in 68-1/2 hours of shooting. During three straight days, he hit 14,560 blocks without a miss. He was born in Boerne in 1869 and toured the country with his wife "Plinky" for half a century. They both gave shooting exhibitions with rifles, shotguns, pistols, and revolvers. He used his .22-caliber Winchester pump gun and approximately 300 bullets to produce his famous pictures of a Native American head in about three minutes of rapid-fire marksmanship, as seen below. Their homestead was a half-mile north of Adler Street on Plant Street. (Below, photograph by Brent Evans.)

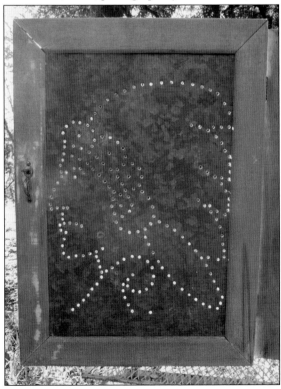

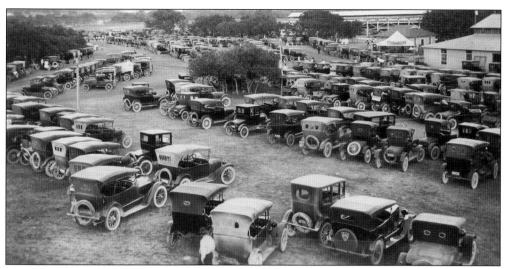

Pictured is the Kendall County Fair of 1922. Today the Kendall County Fairgrounds are used for a variety of events throughout the year, including dances, antique shows, the St. Valentine's Day Massacre Motorcycle Rally, the Cibolo Nature Center Mostly Native Plant Sale, the Boerne Public Library Annual Book Sale, private parties, horse stables, a precinct voting site, and of course, the county fair.

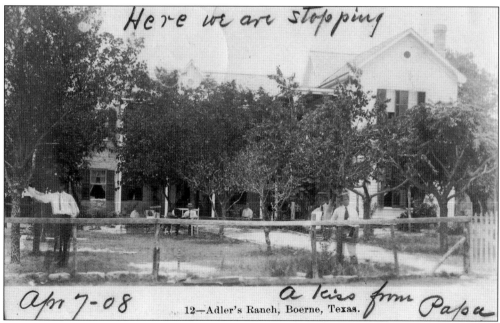

Blacksmith Friedrich Adler and his bride, Juliana, emigrated in the late 1850s. They purchased this rock home in 1881, added on a four-room wing, and took in boarders. They later accepted tuberculosis patients from Dr. Nooe and took on the name Winona Home. The Adlers had two sons, Paul and H. O. In 1929, the four-room wing was sold, disassembled, and rebuilt at 804 North Main Street near the fire station.

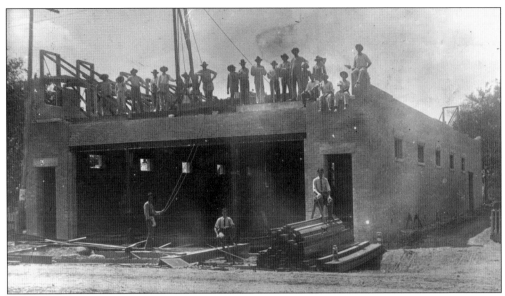

In 1911, Henry Oscar Adler built the Adler Building at 236 South Main Street. The family lived upstairs, and Adler operated a general store on the first floor, A Store of a Million Articles. This was a huge project, with one of the only full basements in Boerne. Adler was an active volunteer in the community and was awarded the coveted Silver Beaver Award by the Boy Scouts.

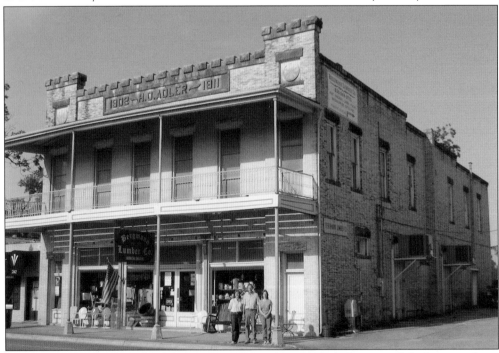

In 1930 the Adler family added wrought iron to the porches and black glass around the lower windows. In 1957 Ruby and Edgar Bergmann founded the Bergmann Lumber Company, and in 1969 they bought the Adler Building, along with the well-preserved pioneer home, the Theis House. In 1994 Randy and Darlene Bergmann undertook an award-wining restoration project. Above Randy and daughters Christina and Shanna operate the oldest hardware store in the county. (Photo Bill Kennon.)

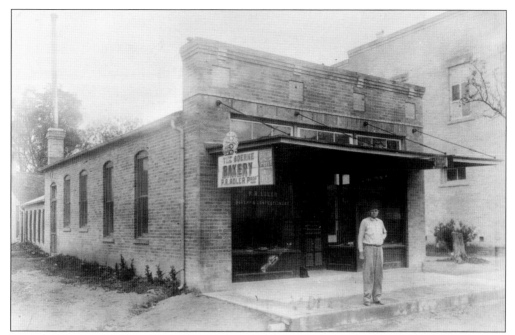

Paul Adler, brother of H. O. Adler, built a bakery next door to the Adler General Store around 1920. The structure would become the Adler Grocery and Dry Goods Store, then a jewelry store, then Quick Realty. Later, the building was attached to the Adler-Bergmann Building, and it is now occupied by Good and Company.

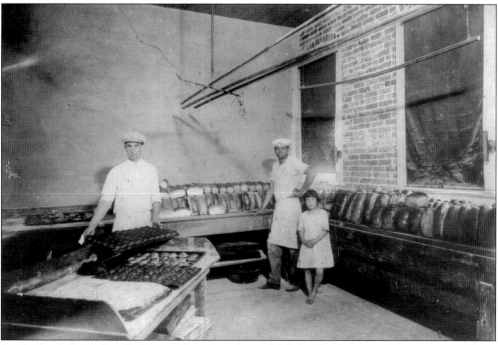

Inside the Adler Bakery, bakers produced staples and delights for shoppers. Boerne seems to have had bakeries from the start. And the bakeries were often the heart of the community, where folks gathered, caught up on local gossip, drank coffee, and purchased bread.

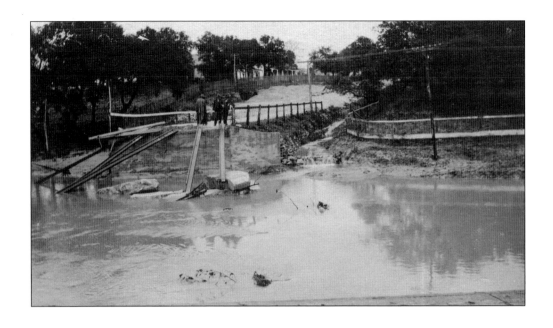

The above 1913 photograph looks south from Main Street at the construction of the first concrete low-water bridge. This major transportation link between San Antonio and Boerne was essential to the town. A $4,000 bond election was passed to pay for the work, and the city paid an interest rate of five percent. Much of the work had to be accomplished with men, mules, muscles, and a lot of leverage. The view below looks west.

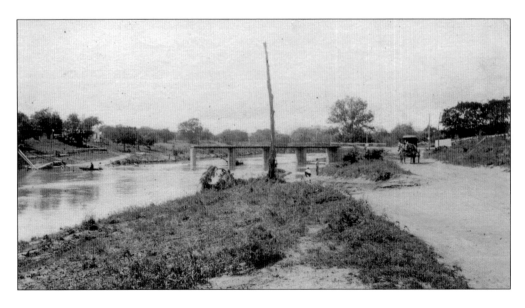

Horses were the primary mode of transportation for many years. Up into the 20th century, the United States was populated by people moving cross-country in horse-drawn wagons. It was not necessary to have modern roads, because the wagons could go across open fields, trails, or even rivers as long as there was room for the vehicle. Toolboxes contained repair parts for wagons and harnesses. (Courtesy Juanita Chipman.)

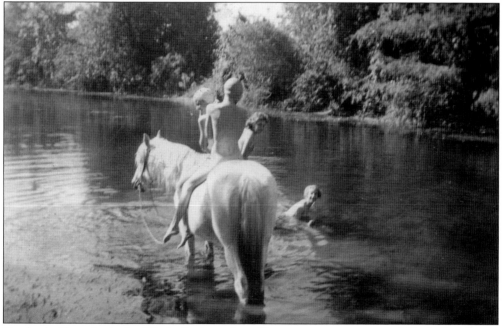

Bareback riders play in the Cibolo. In these days of innocence, youngsters could bath their horses and themselves in the shining Cibolo Creek without a care. Horses were not just the primary mode of transportation but an integral part of the family. Many children grew up riding horses and felt as comfortable on horseback as modern children do in their family cars. (Courtesy Juanita Chipman.)

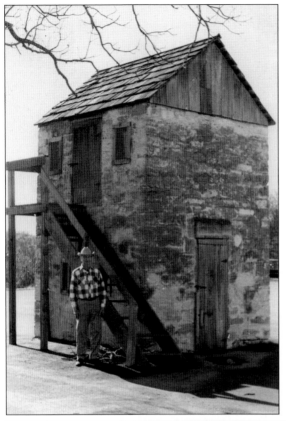

The old Fabra Smokehouse was a one-story meat and sausage curing plant. In 1907, Henry Fabra (left) added a second floor with outside stairs for hanging meat on racks. He would go through neighborhoods in the early-morning hours, hawking fresh meat out of his two-wheeled, horse-drawn cart. The smokehouse has been preserved, receiving a historical marker in 1981. The original log farmhouse on the Fabra farm has been restored, and much of the property is now protected from further development. In 1999, Henry Fabra's grandson Art Wilson spearheaded the founding of the Cibolo Conservancy Land Trust and was the first resident of Kendall County to place his family homestead, the Fabra farm, in a conservation easement. Three generations are pictured below at the old farmhouse. (Below, photograph by Jeff Wilson.)

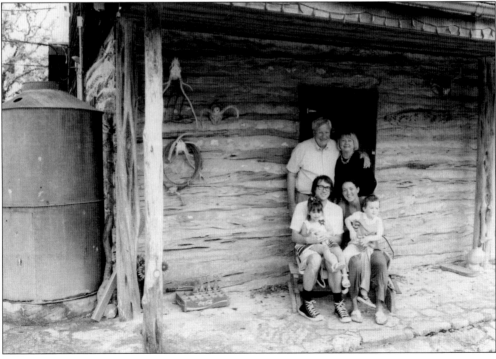

Albert Kutzer was born a native son of Boerne in 1871, the oldest child of Carl Kutzer, who settled in Boerne in 1854 and operated a sawmill and gristmill. Albert was a leading citizen of Boerne and served as mayor from 1915 to 1920. He married Lucie Schwethelm, and they had three children, so naturally he found himself serving on the school board as well.

Albert Kutzer also owned and operated a cotton gin and later acquired the first gasoline distributorship in Boerne. He sold Studebaker and Dodge vehicles as well as implements, wagons, and buggies. His home in Boerne became the First Methodist Church parsonage. Paul Holekamp directed the Gesang Verein, the Singing Society, for 54 years. He eventually acquired the garage building below, and later his family developed Olde Town.

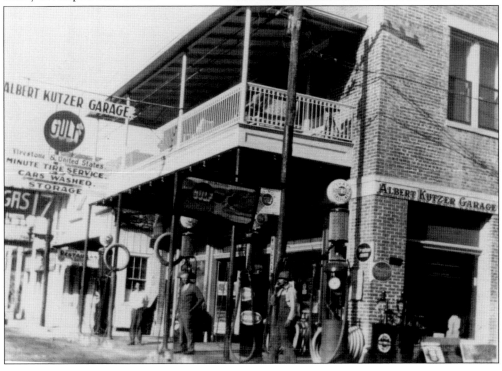

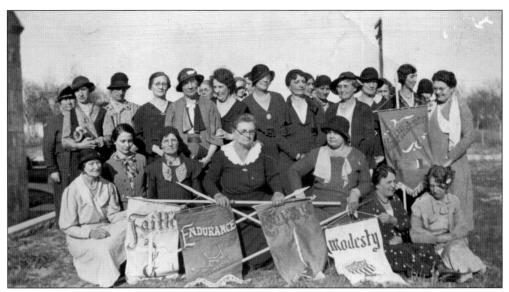

Sonny Davis found this photograph of an unidentified group of women. He thought it was one of the singing clubs, the Gesang Verein. This is not substantiated, but one can plainly see that they believed in faith, endurance, courage, modesty, and unselfishness. (Courtesy Sonny Davis.)

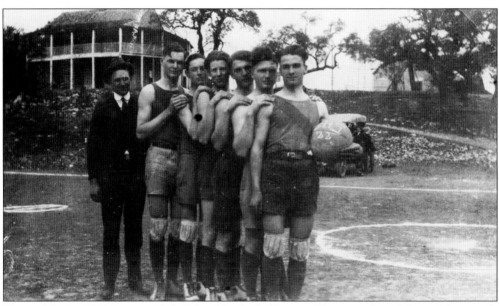

Pictured is the 1921 Boerne High School basketball team. They are, from left to right, coach E. O. Box, J. R. Davis, C. Holekamp, E. Schwope, A. Pfieffer, Ontz Pfieffer, and E. Brown. With the Kuhlman-King Historic House in the background, the basketball court was located behind Boerne High School, which later became Boerne City Hall. (Courtesy Sonny Davis.)

Boerne's first fire association began in 1911. Members were required to answer all alarms and to attend practices. This exempted them from the obligation of roadwork. In 1919, the first motorized firefighting equipment was purchased—a Model T truck, and the City of Boerne took charge of all equipment and bills. In 1929, an American LaFrance fire truck was purchased, and the city began paying for a fire chief and assistant fire chief.

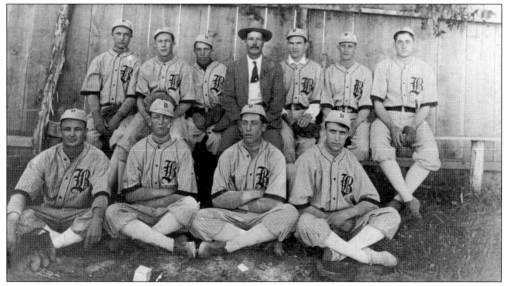

The Boerne White Sox first took the field around 1900. The above photograph is from 1912. In the 1920s and 1930s, the Hill Country League became popular, with spirited rivals playing at Bower Field on Johns Road. The team was disbanded in 1973, only to reemerge recently as part of the Texas Vintage Baseball League, playing by the old rules, without mitts and on rough ground.

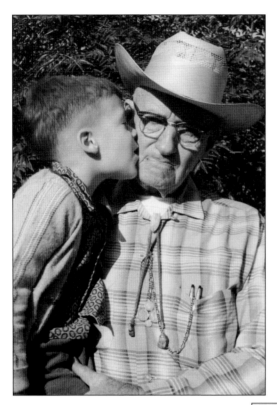

Great-grandson Lee Deviney gives Noel Thomas Insall a kiss in 1964. Insall prospered in the 1930s, ranging over the West, digging oversized walnut roots and shipping the valuable burls to Europe for fine veneered furniture. In 1934, Insall served with the Texas Rangers. As an old man in the 1960s, he spent several years in Arizona's Superstition Mountains mining for uranium. He was also selling Noel-made arrowheads to tourists. (Courtesy Shirley Insall Pieratt.)

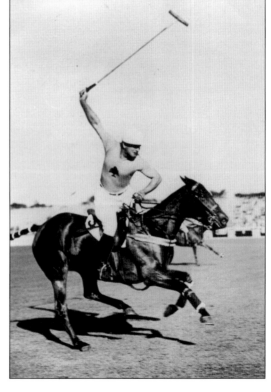

Cowboy Cecil Smith of Llano had been riding horses since he was four years old and ranch-handing since the age of 9, and he ended up in the Texas Sports Hall of Fame. He began his historic polo career in 1933, riding roughshod over the gentlemen athletes of the day, becoming the top-rated player for many years. He retired to train polo ponies at his Pleasant Valley ranch east of Boerne.

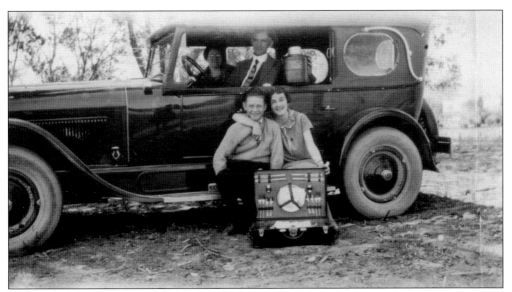

The tradition of taking the family into the countryside for a picnic may be more sacred than any to locals. Townspeople have continued a strong relationship with the land, and occasionally just need to get out and take it all in. In this photograph, an unidentified family is out for the occasion with all the best gear and intentions.

Upper Cibolo Creek Road was a favorite day-trip for Boerne residents for picnicking, fishing, or hunting deer, wild turkey, and mountain lion. This stretch of the Cibolo was always a sleeping giant, waiting for a Texas gully-washer to swell into a major flood. It is the fragile headwaters for the Upper Cibolo Creek watershed and Boerne City Lake.

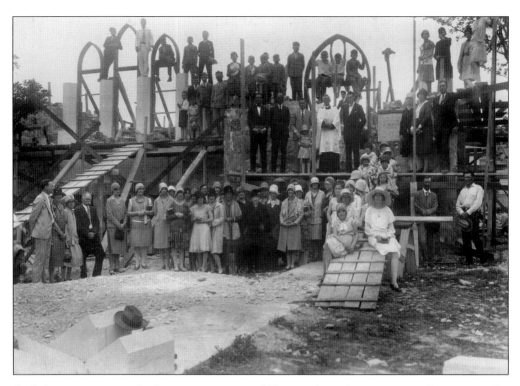

English immigrants to the Boerne area initiated Episcopal worship services in Boerne in 1873 and officially organized a congregation in 1881. St. Helena's first church was a small wooden structure on the site. Construction of the limestone St. Helena's Episcopal Church began in 1929. Like St. Peter's, it was built on a hill outside of the city limits, in the strict Freethinker tradition of separation of church and secular life. The stone structure became a popular place to worship, and some services in German boosted attendance. It was also a great place to catch the next parade.

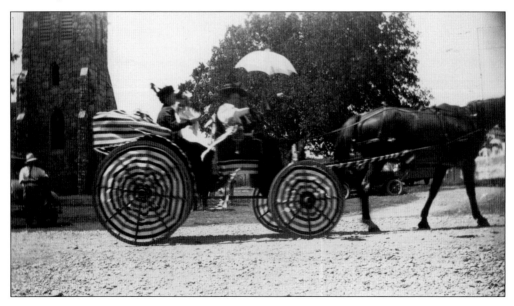

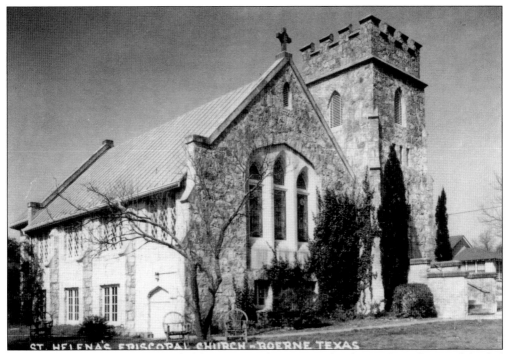

This Gothic Revival stone church (above in 1929) was named to honor St. Helena and funded by a "loved and liberal man in New York " as well as by companions of a deceased Sunday school child whom they wished to honor. The sanctuary was built above ground, and a basement was used for classes and group meetings. Later additions have included educational and office facilities and additional space for a much larger congregation, seen below today. Boerne's Freethinker founders would be amazed at how many churches exist inside the city limits today and how large the congregations have become. Parking is now a major issue for some churches. Local churches provide a great deal of charitable work and support for the less fortunate in Boerne. (Below, photograph by Brent Evans.)

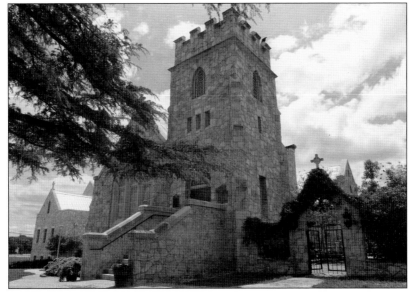

The first property to serve as a community park, the Common Area was established about 1852. There was a cypress water tank where water could be run into a smaller tank for livestock to drink. People could also draw water here for personal use, since not everyone had a well. Sometimes cattle drives would go right down the middle of town, stopping to water in the plaza. The park has become known as Main Plaza. In the 1970s, an onion dome was placed on top of the gazebo, sparking a debate over architecture, but now it is an accepted symbol for the town. The park includes a fountain, sidewalks, electricity, lighting, public restrooms, drinking fountains, and the gazebo, which can be reserved for special events, such as Market Days, the Hauptstrasse Quiltfest, or the vintage car Rod Run.

# *Five*

# CULTURAL HERITAGE

Boerne has inherited a culture with diverse and unique characters and customs that have shaped the town. Here are some snapshots.

Sheriff Lee D'Spain placed this poetry in the *Boerne Star* during one of his campaigns for reelection:

> This sheriff's job is a curious one,
> Like the housewife's job, it's never done . . .
> "Hurry up!" says the caller, "You're badly needed here,
> My husband has a gun and he's full of beer . . . "
> Our only hope and all we can figure,
> Is to be on hand before he pulls the trigger . . .
> So, it's quite a game, if you stay right in.
> You'll get a pat on the back or a sock on the chin.
> But I like it, and I'm shedding no tears,
> And I'd like to be your sheriff for another four years.

Boerne has a long history of selling itself as a spot rich in natural resources. In 1964, the Boerne Chamber of Commerce proclaimed, "Make Boerne your home. High Hills and deep canyons, beautiful trees and scenic drives where you may feast your eyes upon an infinite variety of wild flowers which blanket the hills and valleys in the spring and early summer and the red and gold of the trees in the autumn. Peaceful and picturesque, yet only a few minutes to advantages in San Antonio, Boerne has been designated by the U.S. Health Survey as one of the three healthiest spots in the nation."

When a little one-room limestone building had to be removed from its North Main Street location in 2006, it became a subject of concern for the Boerne Historic Landmark Commission. Some claimed it was the original jail for Boerne, while others thought it was a smokehouse. The structure was eventually dismantled, and has recently been reconstructed on the grounds of Boerne's new Public Library."

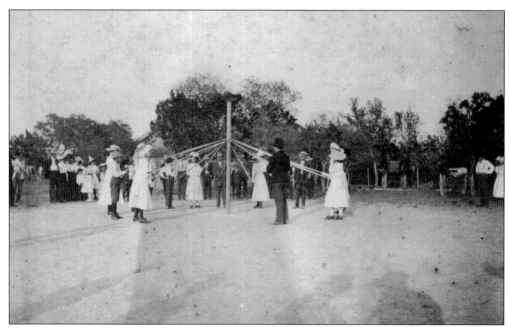

This maypole was featured at the county fair; the date is not known. The maypole is a tradition going back to the 16th century with roots in Germanic paganism. It is a tall wooden pole erected to celebrate either May Day or Midsummer Day. It is often decorated with long, colored ribbons suspended from the top, covered with flowers, draped in greenery, hung with large circular wreaths, or adorned with other symbols or decorations.

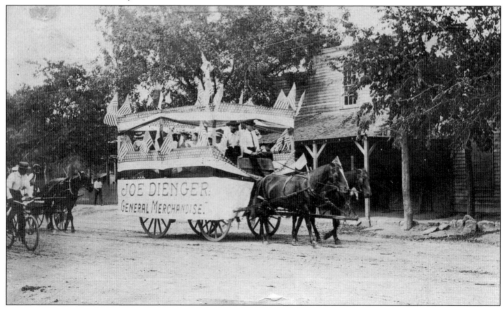

From 1884, Joe Dienger and his family lived upstairs in a landmark structure, with a grocery store downstairs, wood heat, and no indoor plumbing. Dienger was a character with a sense of humor, as seen in the parade float above. The Dienger Building sustained the family until 1967. It displayed many sets of trophy deer antlers from his many hunts and became the Antlers Restaurant in 1969.

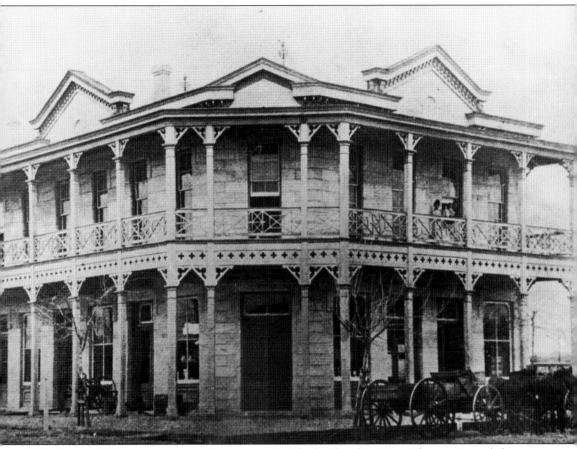

The Dienger Building is at yet another crossroads. The landmark at Main Plaza is pictured above in 1920. Extensive restoration in 1980 preserved the architectural integrity, and it became a Texas Recorded Historical Landmark. In 1984, it was listed on the National Register of Historic Places, and the city purchased it for the Boerne Public Library. The original library was started with 400 books by the Boerne Grange in 1952 in a room next to the old firehouse on the west end of Main Plaza. In 1967, it moved to East Blanco Street, to what is now the police station. Recently, a strongly supported $5-million bond election passed, many private donations followed, and a ground-breaking ceremony was held on May 3, 2010, for the new Patrick Heath Public Library. There is public support both for developing the Dienger Cultural and Heritage Center and for selling the building to help fund the new library. Meanwhile, the building sits in limbo.

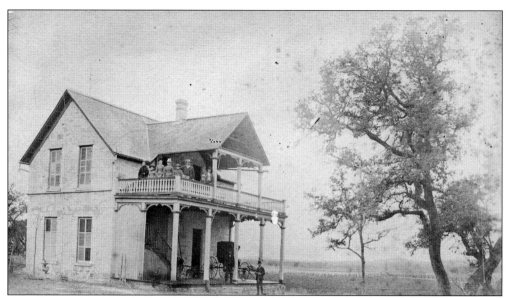

After Bettina, Ferdinand Herff went back to Germany, married Matilde, returned to Boerne, and built a two-story home from fieldstone near Cibolo Creek. He performed a cataract operation in the open air, with primitive instruments, on a Lipan Apache chief who was going blind. While assistants used palm leaf fans to keep the flies away, Herff restored the chief's eyesight. Years later, Lipans spared his homestead from a deadly raid. Herff was the first physician to use anesthesia in Texas. He performed many kinds of surgeries, including the removal of cataracts, washing patients' eyes with boiled rainwater. Following the old medical tradition, Herff performed surgeries on anyone in need, from Texas Rangers and wealthy landowners to the very poor, regardless of ability to pay. He helped found Santa Rosa, San Antonio's first hospital. (Both, courtesy Juanita Chipman.)

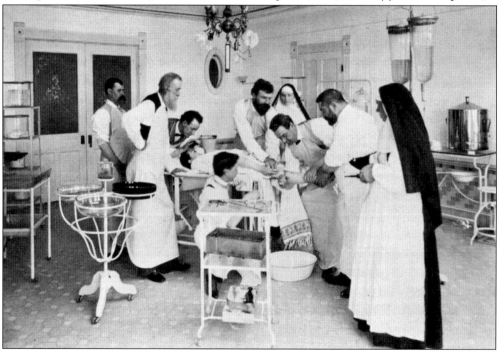

Herff's farm was confiscated by the Confederate army for use as a prisoner-of-war camp. Heritage cypress trees along the Cibolo Creek were cut down, livestock were taken, and the home suspiciously burned down. Herff traveled to Germany briefly, returning after the war ended. He rebuilt his country home in Boerne in 1883, and his holdings expanded to thousands of acres. The farm was sold to the Rozelle family in 1930s.

Erma "Kiddo" Rozelle rode an Allis-Chalmers tractor (still on the farm today) at the Rozelle farm in 1937. In 1935, Col. George Rozelle started Pioneer Apple Orchard, proving fancy apples could be successfully grown in Kendall County. Arriving in 4-foot-by-8-foot crates from Stark Brothers in Missouri, the trees were submerged in the Cibolo until planted. Jerome Ranzau remembered his 1940–1941 agriculture class, under Morris M. Smith, planting apple trees. (Courtesy Rita Rozelle Schimpff.)

Erma and Pete Rozelle pose with Patch in 1940. Colonel Rozelle ice-skated on the Cibolo below their farm. A 1903 West Point graduate, he served with distinction in the First World War, on the vestry of St. Helena's Church, and as the first Democratic chair in Kendall County. Erma taught during World War II and volunteered with the Boerne Historical Society. Pete rode his horse Bunny to Balcones School, studying at night by kerosene lamp. (Courtesy Rita Rozelle Schimpff.)

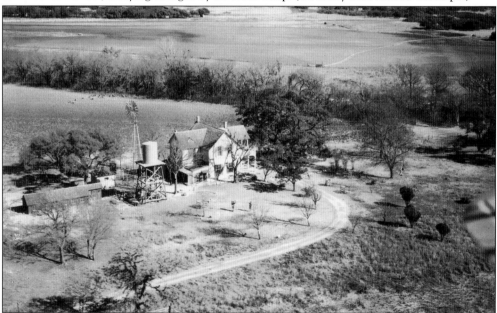

The 62-acre Herff-Rozelle farm was purchased by the Cibolo Nature Center in 2007, with plans to protect the natural area, restore the historic compound, and develop agricultural and educational programs for the public. It is listed on the National Register of Historic Places by the Department of the Interior. Vintage baseball games are played on the farm, and a Living History Festival was held there.

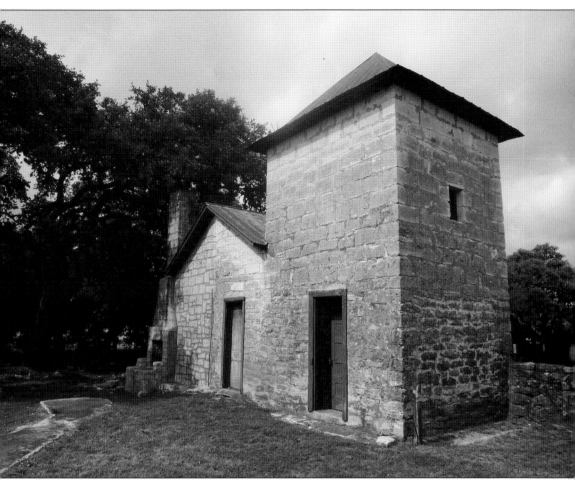

This small rock house and tower served as an effective defense against "Indian attacks." The Menger-Kingsbury-Shumard compound was slated to become a Super Walmart parking lot. The Kendall County Historic Commission worked with the Bakke Development Corporation (donated the property), Walmart (donated one acre of land), and the City of Boerne (purchased the outbuildings and restored the main house as the Boerne Visitor Center). (Photograph by Brent Evans.)

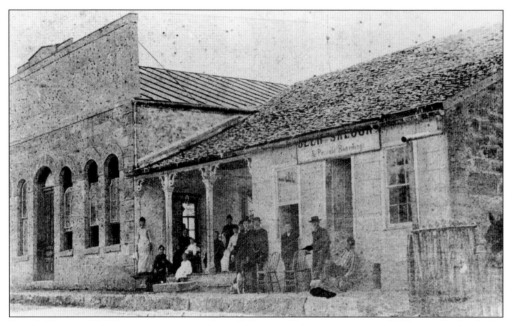

Joseph Vincent Phillip was a carpenter from Bohemia. During the war with Mexico, he built the first bridge across the San Antonio River, giving Texans a strategic advantage. Phillip moved to the Hill Country, lived in a cavern for years, settled in Kreutzberg, and then owned a single-story stone house in Boerne that would become Phillip Manor, seen above in 1870. He built the original Kendall County Courthouse.

In 1878, a saloon wing and athletic wing were added to Phillip Manor. A second floor was added for guests in 1880. The building has been a stagecoach stop, an inn, an athletic club, a shooting club, a saloon, a dance hall, a polo club, and a social center for the community, as seen above in 1900. In 1910, a kitchen wing was built, with more rooms added above.

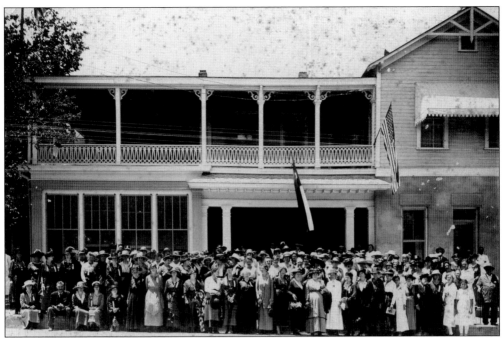

Above is a photograph of Phillip Manor in 1920. The property was sold in 1927 and served as a hotel into the 1960s. Howard and Judy Calder restored the building in 1980, and it became Calder's London House Pub, and then a variety of businesses occupied the grounds. Phillip Manor is now undergoing a major restoration project under the ownership of Debbie Gracy, who envisions a vibrant community hub. She says, "My vision is to bring Phillip Manor full circle making it once again a destination and community gathering place." A stone wall will surround an acre of gardens, creating an intimate space to buffer noisy Main Street. Limestone was quarried in Sisterdale, and the building technique was the same used by master stonemasons in the era of the original Phillip Manor. All stones were hand-beveled using hammer and chisel.

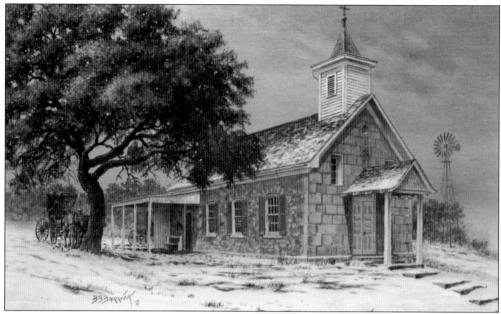

Legend has it that the "Freethinking" Germans forbade churches to be built within Boerne city limits for years. The first church, St. Peter the Apostle Catholic Church, was built on a hill outside the city in 1867, financed by George William Kendall for his Catholic wife. His family was uprooted and had to move many times when he was young, but in Cibolo Valley, Kendall found his home.

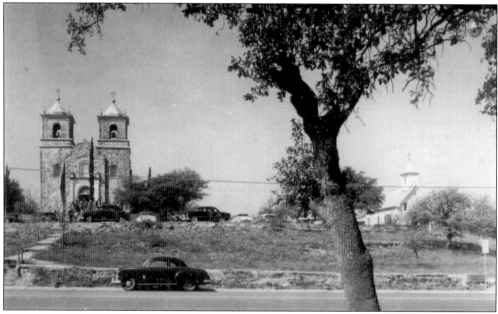

The second St. Peter's Church structure was built with twin Spanish Mission–style towers in 1923. The building was designed to seat 200 people. In 1980, the congregation was growing rapidly to over 700, and plans for expansion began. Discussions ensued over whether to completely raze the building or to save at least a portion of it. The issue ignited many divisions within the church and the larger community.

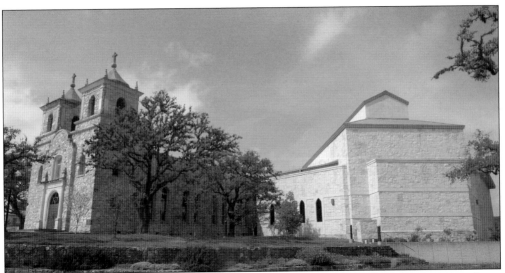

In 1993, the Boerne Historic Landmark Commission rejected the church's request to tear down 80 percent of St. Peter's to make room for expansion. The argument went all the way to the U.S. Supreme Court in 1997, and a landmark decision strengthened historic preservation ordinances nationally. The city and the church eventually compromised, and 75 percent of the building was retained. (Photograph by Brent Evans.)

In 1961, the Congregation of Benedictine Sisters purchased Kronkosky Hill from Albert Kronkosky Jr. They founded a parochial school and renovated the water tower building for a school library. The sisters established St. Scholastica Monastery, served Head Start students, and created a Health and Wholeness Center, including a swimming pool for seniors 55 and older. Their good work is known throughout the Hill Country.

In this 1949 photograph, Consuelo Montez stands in front of the first Mexican American dance hall in Boerne, the old Montez Dance Hall. The structure was built on Iron Street in the Flats around 1945, and neighbors still remember soldiers showing up for dances. (Courtesy Tillie Fass.)

The third-grade class of 1946 poses on the steps of its school. The building now serves as Boerne City Hall. Some are barefoot, and Tillie Fass (first row, second from left) is holding hands with her friend in spite of widespread segregation rules in the broader community. Fass says children made friends anyway. (Courtesy Tillie Fass.)

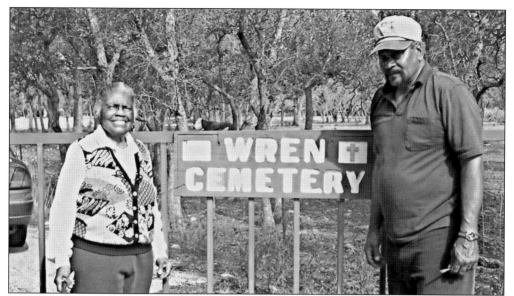

Charlotte Oneil Wren now lives in California. She grew up in Boerne and remembers when the black children were only permitted to swim in the Boerne Municipal Swimming Pool one day per month—the day the pool was emptied for cleaning. The last name on Boerne's World War I Memorial is Jack Oneil Wren. Above, family members care for their old family cemetery. (Photograph by Brent Evans.)

In 1920, the Royal School was the "Colored School," located in the Flats. By 1958, there was one African American family with school-age children in Boerne. Voters were asked to permit "two negro pupils," Louise Farrell, 11, and Willie Earl Farrell, 10, to attend the white elementary school. Residents rejected integration of the school by a vote of 183 to 146. Only later were the Farrell children permitted to attend public school.

The Boerne Turn Verein is a nonprofit social and athletic club incorporated in 1906. It was organized around 1878, meeting in the old Dienger Hall, later moving to the south wing of the Phillip House. In 1903, the group built a four-alley clubhouse, which was destroyed by fire in 1948. Members then built a "fireproof" eight-alley hall, which stands today. According to their Web page, "The Turn Verein operates a bowling club for the physical development and social entertainment of its members in a safe, family oriented atmosphere, with membership open to all, and children are welcome." Pictured above is the Boerne Turn Verein Team, including, from left to right, Ida Bergmann, Louise Menhennet, Alice Gerfers, Emmie Weeaks, and Babe Bauer. Below is the Boerne Turn Verein today. Some citizens express concern about its future. Roll on, bowlers. May the Turn Verein abide! (Below, photograph by Brent Evans.)

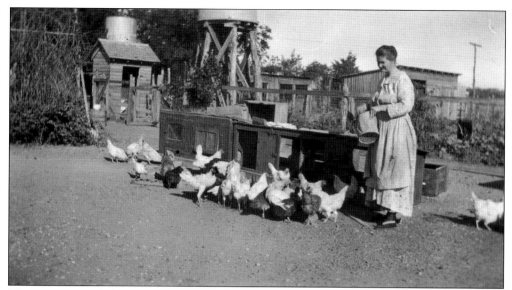

Mamie Davis tended chickens at Theissen and Turner Streets years ago. In 2007, a few concerned citizens sought to limit the number of fowl per family to eight hens and "no more than one male chicken after it is old enough to crow." The proposal was rejected by the city council, preserving the rural nature of the community and making for happy roosters. (Courtesy Sonny Davis.)

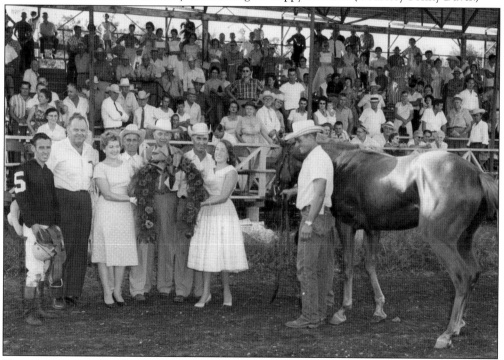

Horse racing was popular at the Kendall County Fairgrounds from the beginnings of the fair. Celebrations would include square dancing, parades, exhibits, cowboy camp and chuck-wagons, German beer garden, baseball games, fiddlers contests, Fiesta Night dances, crowning of queens, jumping horses, and horse races. Many old-timers still remember riding their horses on Boerne's Main Street, and cowboy hats still outnumber baseball caps at the fairgrounds.

In 1955, the big attraction for kids was the merry-go-round in Main Plaza. The merry-go-round was located a little to the south of the plaza between San Antonio Street and Blanco Road. It was a place for innocent fun. John Eddie Vogt remembers that when a couple of toughs had a battle to settle, it was common to hear them say, "Meet you at the merry-go-round after school." (Courtesy Tillie Fass.)

In 1955, Deloris Alverez (left) and Nancy Garcia (right) pose at the fountain made of native honeycomb limestone in Main Plaza. By 2003, the catch basin had sprung a leak. Some called it a "pile of rocks." So it was decided to scrap the old fountain in favor of, as recorded by the Boerne City Council, a "more natural-looking water feature evocative of a Hill Country spring or pond." (Courtesy Tillie Fass.)

The Plaza Theater was across the street from Main Plaza. Seating was segregated, with "Whites on the right, Mexicans" on the left, and "Negroes" in the balcony. Since there were only a few African American families in those days, adventurous youth would head for the balcony. *Revenge of the Creature* was playing on Sunday and Monday nights according to the marquee in the photograph at right. (Courtesy Tillie Fass.)

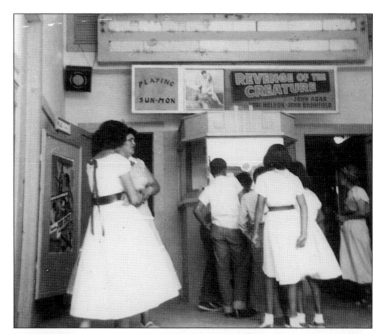

Master beekeeper Louis Keubel has kept bees since 1965, having at times over 200 hives, each capable of producing 35 pounds of honey. Keubel helped many apiary hobbyists get started. Africanized bees, mites, and die-offs have recently caused severe losses. Keubel is also skilled in water witching. It is "God given," he says. "Some people can do it, but most can't." He uses copper rods. (Photograph by Emilio Scoti.)

In 1967, Interstate 10 reduced traffic through town, and there were gloomy business predictions. The Boerne Chamber of Commerce and the Boerne Lions Club organized Berges Fest ("Hill Country Festival"), which is now a tradition. Empty store windows were decorated. Boy Scouts cleaned the windows, and citizens decorated them with quilts and antiques. The City of Boerne pitched in with electricity and clean-up crews on Main Plaza. The volunteer fire department used to hand out free beers from the fire trucks in the parade on Saturday mornings, but they were eventually required to stop that part of the tradition. Below is one of the many Berges Fest parades, led by Arley Sultenfuss, Jack Esser, and two unflappable horses. (Both, courtesy Sonny Davis.)

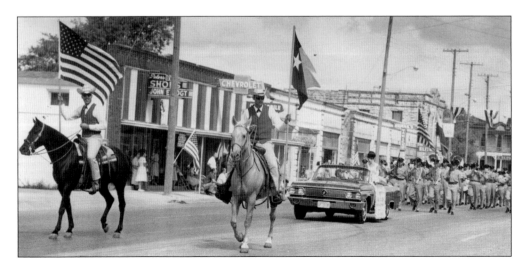

Small family-owned restaurants are a tradition in Boerne, even though many have given way to the new economy of high-end establishments and franchises. The legendary Beef and Brew Restaurant was owned and operated by Lou and Mary Lou Borgman for 24 years and offered incredible hamburgers. The couple also operated Borgman's Sunday House Bed and Breakfast Inn. They celebrated their 50th wedding anniversary in 2006. (Courtesy the Borgmans.)

In 1983, Larry Waldeck named his store the Red and White Market; later it was Larry's Piggly Wiggly and later still Larry's Meat Market. It is now Farmers Market, with great barbecue and select meat cuts. Its deer locker provides hunters with heart-healthy venison. From left to right are happy customer Tom Brown and employees Walter Nye, Claire Klein (current owner), Bonnie MacDonald, and Gavin Waldeck, Larry's son and a previous owner. (Photograph by Brent Evans.)

Bigs General Store was a fixture in Boerne. In 1954, Bigs was operated by Alice Gerfers (above). Mitchell Cleaners was where Johnny's Feed and Supply is now. Bigs was purchased by Bob and Carole Buendia in 1980 and continued operating as a general store. It is now occupied by Johnny's Feed and Supply, the Red Crest Pet Shop, and Boerne Grooming for pets. (Below, photograph by Kip Kiphart.)

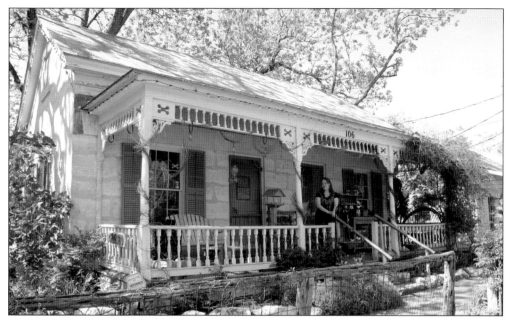

Gottlieb Adolph Weiss built this house and a blacksmith shop on Theissen Street in 1887. The porch was added in 1907, and the home stayed in the Weiss family for over 100 years. The building now houses A Little Nature Store, owned and operated by Patti Roetman. The front yard remains green and inviting, a great place relax and hear birdsongs in the middle of town. (Courtesy Kip Kiphart.)

In 1987, a landscape ordinance proposed to save green space and heritage trees, like the one above at the old Kingsbury residence. Realtor Guy Chipman Jr. said, "I have seen a lot of the charm of Boerne disappear. This is a chance to control growth and attract new businesses and people. You have an opportunity that you may not have in the future." A compromise ordinance passed. (Courtesy *Boerne Star*.)

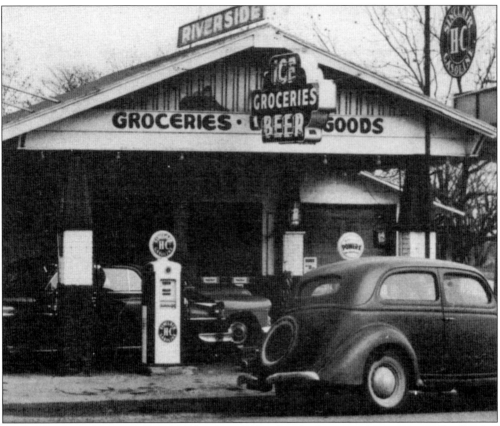

Since the 1950s, the Riverside Market has hosted the "best barbecue in the territory." The flood of 1962 demolished the store, but it was rebuilt and continued its tradition. Purchased by Harold and Mary Lou Zoeller in 1979, it offers a traditional butcher shop, fresh produce, groceries, gasoline, fishing supplies, and food for the ducks along River Road. Manuel and Pancho Lozano worked at the store for over 35 years.

The celebrated "Guardian Gander" was mortally injured when hit on River Road while protecting his nest at the Dodging Duck Brewhaus. Volunteers stepped up: J. J. Blackson of the Hill Country Animal Defense League transported him to Wildlife Rescue; others built a nest enclosure; and a step-gander joined the family when they were released. Memorial services included bagpipes, the goose family at left, and mourners spreading gander ashes on the Cibolo.

Hispanic citizens organized the Crusaders Club in 1969 and built Crusaders Hall in 1978 for meetings and social gatherings. Grassroots activism provided fund-raising, construction know-how, building materials, and elbow grease. Robert Salinas, Lupe Rodriguez, MaryAnn Perez, George and Bedelia Mitchell, Antonio and Anita Valenciano, and many others helped the neighborhood dream come true. Here Antonio Valenciano Jr. (center) and sons Richard and Antonio III install a new sign around 1990.

During the age of chain restaurants, Mague Ramero opened Mague's Mexican Restaurant in 1989 and runs it with her daughters—Claudia, Corina, and Brenda. Ramero came by her recipes and skills as a native of Mexico, moved to Texas, and started serving breakfast, lunch, and dinner with famous fresh pico de gallo. The mural on the side of the building calls out, "Cultivate Culture and Community." (Photograph by Brent Evans.)

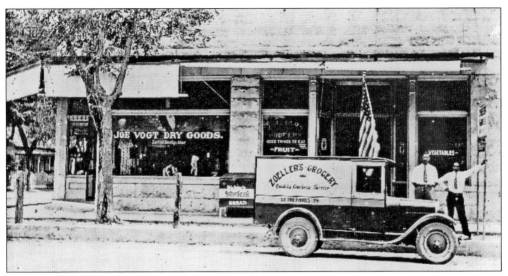

Joe Vogt started out hauling goods from San Antonio to Boerne with oxen and horse-drawn wagons. Then he bought the corner property on Theissen and South Main Streets and built the Joe Vogt Building in 1912 for a grocery and dry goods store. This image dates from the era of the Vogt Dry Goods Store and the Zoeller Grocery. The Zoeller family later purchased the Riverside and continued a market tradition.

Joe Vogt built this landmark stone building in 1912. In 1965, the Wertheims turned it into the Hill Country Bakery. Patrick Heath operated the bakery in 1984. In the 1990s, Paula Hayward and Jack Cushman renovated the building and founded the Bear Moon Bakery. Words are inscribed on a stone on the shelf: "'The mission of the community bakery is to nourish the community heart.' —Noblsavaj." (Photograph by Brent Evans.)

"Boerne Bear Eludes Capture!" read headlines in 1980. Sheriff Glynn White and the game warden staked out the ranch where eight sheep were killed. At 3:00 a.m., the bear returned. Corky Corcoran reported: "This proved to be more than the hunters could bear, so they drew a bead on the big black and squeezed of three shots. The elusive animal however escaped untouched as he knocked down a fence and jumped over to race to freedom. It was at this point that the bear rung up his only injury of the day as Sheriff White caught his foot in the hay loft ladder and suffered severe injury to his ankle . . . Until this killer bear is captured or slain, the residents of Kendall County are going to have to grin and bear it." (Photograph by Jonah Evans; story courtesy *Boerne Star.*)

Patrick Heath was Boerne's longest serving mayor (20 years). He is remembered for his consensus-building skills on city council and his advocacy for libraries, Texas libraries in particular. Heath played an instrumental role in acquiring the Dienger Building in the late 1980s for the town library. His wife, Carla, was a very active volunteer in the community. Construction of the 30,000-square-foot Patrick Heath Public Library is now underway.

Sam Champion attended Boerne schools and became principal of Boerne High School. When spring break arrived, he would dump some sand on campus, sit under an umbrella with Hawaiian shirt, shorts, dark glasses, and zinc oxide nose, and admonish students to be careful during their vacation. After his cancer diagnosis, Champion founded the Sam's Kids program, helping students with special needs. The new high school was named in his honor.

Bedelia and the late George Mitchell were prominent business and community leaders. Bedelia, known as "Mrs. PTA," possessed "civic mindedness very likely unequaled by any other in this community," as noted in the April 10, 1969, *Boerne Star*. George was with the chamber of commerce, Lions Club, Berges Fest, and Boerne Youth Athletic Association. Both participated in the many Crusaders Club projects around town. They were from "old families," hers from the De Leon colony in Victoria County and his from Goliad County.

Hilmar Bergmann began working for the soil conservation service in the 1950s. He lived his life on the ranch where he was born. After retiring, Bergmann volunteered, documenting plant life and producing brochures describing grasses and woody plants in Kendall County. He hauled around a flatbed trailer full of native plants to teach with. Bergmann said, "In this prairie you can find around 60 different grasses. Isn't that somethin'."

The Boerne Area Historical Preservation Society was formed to "engage in and encourage the preservation of the natural beauty of the community and of historical buildings, objects, and places, thus keeping legible the history of the Boerne area to the end that knowledge of the rich historic and inherited community values may be widely appreciate and not be lost." (Photograph by Ralph Lay.)

The Native Plant Society of Texas began in 1980. Thanks to its tireless work, newspaper articles, and educational programs, many residents are now landscaping with native varieties of plants and trees, and Boerne is a greener place. The Boerne chapter has donated thousands of hours of volunteer planting of natives at Boerne Lake, the Old No. 9 Greenway, the Cibolo Nature Center, and all around town with the Big Tooth Maples Program.

The volunteer fire department had a traditional warning siren—two blasts was fire in the county, three blasts was fire in the city. A super-long blast would mean tornado or "the big one." At noon each day, the siren was tested. Once the siren sounded, pickup trucks would race to firehouse. The department now has sophisticated communication devices, but the tradition of the noon whistle lives on.

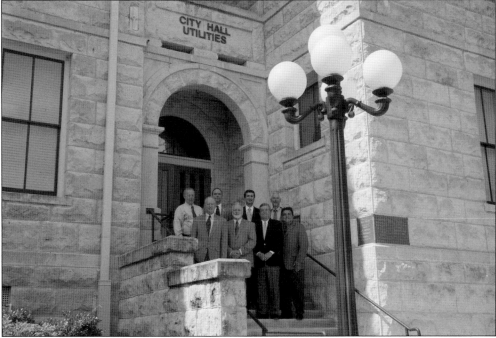

As in all beautiful and booming communities, local leaders face choices about conservation issues, commercial interests, and the public good. Pictured at the historic City Hall and Utilities Building are, from left to right (first row) Mayor Dan Heckler and councilmen Bob Manning, Rob Ziegler, and Jacques DuBose; (second row) councilmen Ron Warden and Jeff Haberstroh, city manager Ron Bowman, and assistant city manger Jeff Thompson. (Photograph by Ralph Lay.)

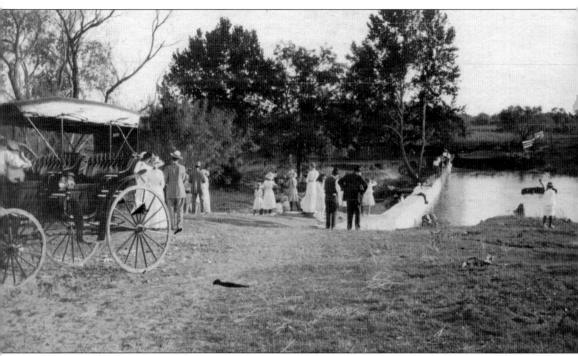

In 1890, the Boerne Campers Association advertised: "Come camp along the banks of the Cibolo, to be provided with tents, food, and all the necessities by local businesses." Boerne continues to successfully market itself as a beautiful place to visit or live. But Boerne needs to grow in a way that does not "kill the goose that laid the golden egg." Its greatest treasure is its most fragile resource. Everyone must hope that the city holds on to its natural heritage. Lady Bird Johnson once said, "In my own experience, nature was encountered most intimately when I left the city to go to our ranch. . . . I rediscovered a sense of caring and a sense of smell from the perfume of blossoms and grasses after a rain. This participation in the seasons and the weather is one of the most vital and renewing experiences of life—too important to be reserved for vacations for the few."

*Six*

# NATURAL HERITAGE

In 1800, about 30 million bison thundered over the Great Plains. By 1889, only 551 buffalo could be found in North America. In the 1830s, Cibolo Valley settlers saw buffalo near the Rio Cibolo by the hundreds. Settlers waited for three days at one Cibolo crossing while a giant herd of buffalo rested and crossed. The buffalo were gone by 1849, and other species were fast disappearing. F. L. Olmsted wrote in 1854: "There was still, at a spot near Currie's Creek, a man who made his livelihood by hunting. He kept a pack of trained hounds and had killed 60 bears in the course of two years."

The Texas prairies reminded early explorers of the seas they had sailed across. Native grasses with prairie chicken communities flourished as far as the eye could see. By the late 1850s, the prairie had been vastly altered by cattle, sheep, goats, and burning. The plow did its share, and by 1860 there existed only small remnants of those original seas of grass. Some 100 years later, soil conservation agent Hilmar Bergmann continued to insist, "Our soil is our wealth."

Giant bald cypress trees were valuable to the early explorers because of their water-resistant qualities. They were good for shingles, water tanks, beams, and even charcoal. Hugo Claus wrote in 1875: "On the opposite of the mountain chain toward the north of Boerne Texas, flows the Guadalupe River, a beautiful river, fish laden shaded with giant cypresses which now unfortunately have mostly disappeared."

In 1990, Kendall County was declared a Critical Groundwater Area by the Texas Water Commission, which noted that water availability and quality will be at risk within the next 50 years. The Rule of Capture was permitting unregulated groundwater pumping. In 2002, voters supported creation of the Cow Creek Ground Water Conservation District.

As the population of the Hill Country grows, and more development occurs, there is also a growing awareness of what could be lost and what needs to be saved—the views, the rich wildlife habitats, the river and creek corridors, and the aquifers beneath.

In 1984, Judge Garland Perry wrote in *A History of Kendall County Texas*, "In 1835 the Texas Hill Country was said to have been one of the most beautiful natural areas on earth. It had tall grass, beautiful trees, and fresh, clear running water throughout the area. What the early settlers were unaware of was that immediately beneath that rich, lush, organic topsoil—saturated with moisture—was nothing but hard limestone rock."

Sunny Brook, Walnut Grove Ranch.

Judge Perry continued, "The first settlers to reach the Hill Country always camped near a spring of good water, or near a stream, where they built their temporary homes. Then they started clearing land, fencing and planting crops." Pictured is a scene from Walnut Grove, near Boerne.

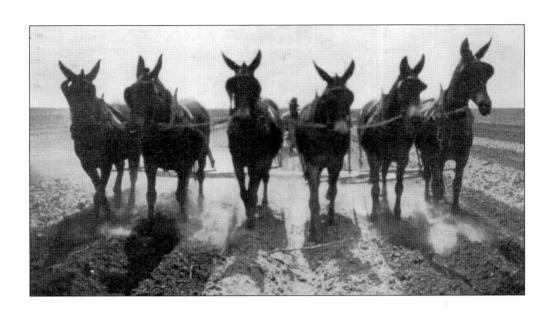

Judge Perry concluded, "As they plowed more land and began to overgraze grasslands with domestic animals, the rains soon washed the topsoil away. Without the organic matter to hold moisture in the soil, springs soon went dry and it was necessary for the settlers to move near larger streams of water or to dig shallow wells . . . Between 1860 and 1880, good well water could be reached at 30 to 35 feet. By 1900, windmills were very popular . . . extracting water from 100 to 125 feet . . . Now, a great many of the private water wells are getting water at 500 to 550 feet below the surface. Obviously, this trend can't go on forever. Water will be a limiting factor in the future growth and development of Kendall County." Below, young well-drillers operate dangerous machinery.

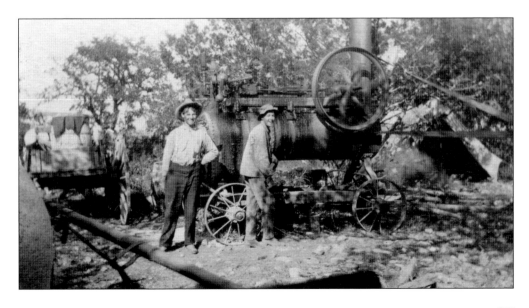

Boerne residents have long celebrated the Cibolo Creek. In 1890, the creekside was advertised by the Merchants Association of Boerne in the *San Antonio Daily Express* as "a beautiful park-like piece of ground shaded by live oak and other timber fronting the whole distance upon the Cibolo River, one of the most charming mountain streams in the whole State, pure running water over a gravel bed, as clear as a crystal." (Courtesy Sonny Davis.)

"There are pools 5 to 6 foot deep in which grown people can enjoy a bath and between the pools the water is so shallow that the merest little toddler may be allowed to go in with perfect safety. No harm comes from bathing here, our boys often go in five or six times a day and nearly every night and no bad results," wrote the Boerne Campers Association in 1890.

Recreation along the Cibolo also meant horseback riding, hunting, fishing, and picnics. "The place has long been and is still used for picnic grounds and admired as spring of good pure wholesome water running out of the bank and the river affords good fishing and bathing facilities," according to the Boerne Merchants Association. (Courtesy Juanita Chipman.)

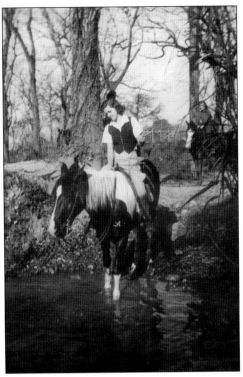

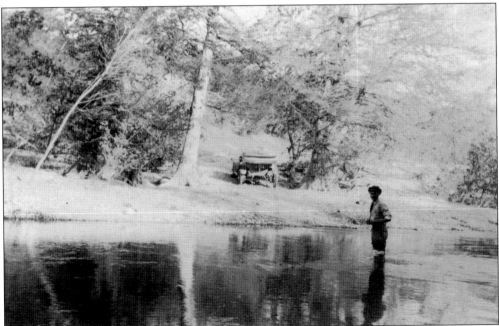

*The Handbook of Texas* states, "Throughout its course, Cibolo Creek has been judged to be a 'scenic' and 'picturesque' stream. This is particularly true as it passes through Kendall County where a steady flow serves as the basis for Cibolo Nature Center near Boerne. The stream has been dammed to create Boerne City Lake, which provides drinking water for the town's residents. Further downstream, the creek contributes to the formation of Cascade Caverns."

In 1962, Cibolo Creek produced massive flooding, destroying the Riverside Market and washing away houses behind Sach's garage and homes in the Flats. Businesses along River Road were flooded, and one life was lost. The old ice plant building had a slanted floor for drainage, which helped considerably during the cleanup. This flood spurred the planning for flood control by damming the Upper Cibolo. (Courtesy Sonny Davis.)

Construction of the John D. Reed Dam at Boerne City Lake is seen in 1976. The lake opened in 1978. The initial purposes of the dam were flood control and a future water supply. John D. Reed had been the district conservationist for the soil conservation service. He said, "Most ranchers were satisfied with overstocked and poorly managed ranges. . . . [But] conservation of natural resources is now an accepted way of life."

In 2002, torrential rains caused the Upper Cibolo to explode out of its banks and overrun the spillway, uncovering dinosaur tracks. Chris Turk, director of planning for the City of Boerne, examines the tracks of what experts called Acrocanthosaurus, a fabulously fierce-looking, short and stocky Tyrannosaurus rex relative. The tracks were cast and duplicated at the Cibolo Nature Center, thanks to the Lende Foundation. (Courtesy Chris Turk.)

Volunteers pick up trash at Boerne Lake. Keep Boerne Beautiful, founded by Judy Edmondson, has been holding local creek cleanups and lake cleanups for years. This award-winning grassroots environmental initiative turns out hundreds of volunteers for these events. (Photograph by Brent Evans.)

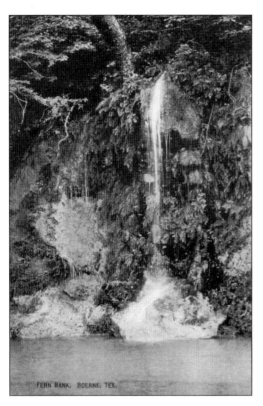

FERN BANK, BOERNE, TEX.

In 1981, Bill Lende assembled several properties along Cibolo Creek to create his 600-acre Herff Falls Ranch. With these acquisitions he became the steward of three treasured Boerne landmarks: the Fern Bank, Herff Falls, and Cibolo Canyon, together with 1.5 miles of Cibolo Creek that connects them.

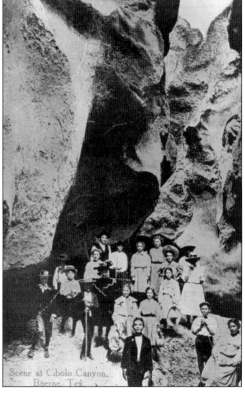

Scene at Cibolo Canyon, Boerne, Tex.

For 27 years, Lende operated the ranch as a working farm, raising blackberries, table grapes, and axis deer for local markets. In 2008, to protect these three Boerne landmarks, Cibolo Creek, and the 500 acres surrounding them, Lende created the Cibolo Preserve, a nonprofit private operating foundation to which he donated the property.

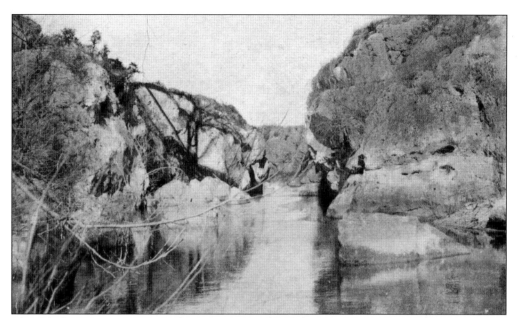

The Cibolo Preserve is managed as a unique outdoor laboratory for preservation, research, and education. The preserve has selected Texas Parks and Wildlife Department, Cibolo Nature Center, and the University of Texas at San Antonio to conduct research on the property. It has been endowed by the Lende Foundation.

The railroad right-of-way that runs through the heart of Boerne was a natural trail just waiting to happen. Now it is a popular place to stroll, jog, walk a dog, or push a baby carriage. The City of Boerne maintains the trail, and the Native Plant Society has landscaped the trailheads. Green zones are planned along some town creeks, with trails connecting.

In 1988, a few citizens asked the City of Boerne to allow the building of nature trails in City Park. In 1989, the City of Boerne and volunteers restored a marsh area, planted cypress, sycamore, and dogwood trees, and built a boardwalk. The volunteers founded a grassroots nonprofit organization with a mission of promoting conservation of natural resources through education and stewardship. In 1992, the Cibolo Nature Center celebrated the grand opening of its new headquarters, a vintage 1898 building moved and recycled from Main Street. The park's green space is open to the public, with nature trails winding through oak and juniper woodland, along cypress-lined Cibolo Creek, and through a native tall grass prairie and the marsh. It is a site for school field trips and award-winning educational and research programs and is an oasis of quiet recreation. (Both, courtesy Cibolo Nature Center.)

The Cibolo Nature Center (CNC) leases 100 acres of City Park, protecting the creekside, upland woods, marsh, and native prairie areas. Prairie restoration began with prescribed burns and mowing, which promote the growth of native grasses. Pictured from left to right are CNC executive director Carolyn Chipman Evans and education director Jan Wrede, retiring after 20 years of service to the community. (Courtesy Cibolo Nature Center.)

In 2005, the CNC celebrated the grand opening of the Lende Learning Center, including an auditorium, library, laboratory, business office, research lab, and Texas Parks and Wildlife Department office. The CNC provides regional conservation leadership through model education and stewardship programs and promotes the conservation of the Cibolo Creek Corridor. Many towns have used the CNC's *Nature Center Book* to start and grow their own nature centers. (Courtesy Cibolo Nature Center.)

Mayor Patrick Heath cuts the ribbon for the Old No. 9 Greenway in 2001. The Friends of the Cibolo Wilderness partnered with the city to win a Texas Parks and Wildlife Department grant to convert an abandoned railroad right-of-way into a hike-and-bike trail. The Old No. 9 Greenway was part of 150 acres that the city had designated as permanent green space during Boerne's 150th year. (Courtesy Paul Barwick.)

In 2004, Kendall County commissioners met with the Trust for Public Land, Cibolo Nature Center, Texas Nature Conservancy, Texas Parks and Wildlife, Land Trust Alliance, and the Cibolo Conservancy Land Trust. A master plan was adopted, a $5-million bond was passed, and 600 acres of parks and natural areas were purchased. The effort received the 2006 Environmental Excellence Award from the Texas Commission for Environmental Quality. (Photograph by Brent Evans.)

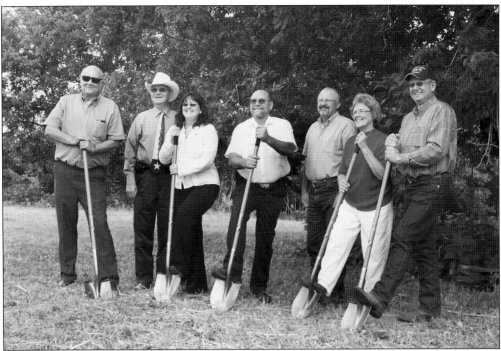

In 2005, the first parcel of "Prop One" parkland was purchased on River Bend Road at the Guadalupe River. The Kendall County Partnership for Parks administered a grant from the Kronkosky Foundation to provide improvements. It was dedicated to the memory of U.S. Army specialist James M. Kiehl, who was lost in the Iraq War. Pictured above are his parents and the Kendall County Commissioners Court. Here's hoping the Hill Country stays "country," and that folks will always be able to get down to the river. And here's hoping that Boerne can grow gracefully, saving its canopy of trees and beautiful streams, its architecture and historic landmarks, its parks and trails, its dark night skies, its neighborhoods and family businesses, its unique songs and stories, and the diversity of its people and landscapes. (Both photographs by Brent Evans.)

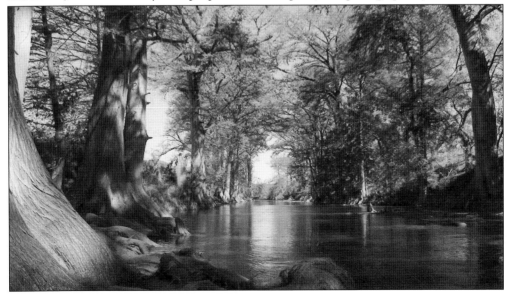

# Discover Thousands of Local History Books
## Featuring Millions of Vintage Images

Arcadia Publishing, the leading local history publisher in the United States, is committed to making history accessible and meaningful through publishing books that celebrate and preserve the heritage of America's people and places.

Find more books like this at
## www.arcadiapublishing.com

Search for your hometown history, your old stomping grounds, and even your favorite sports team.

Consistent with our mission to preserve history on a local level, this book was printed in South Carolina on American-made paper and manufactured entirely in the United States. Products carrying the accredited Forest Stewardship Council (FSC) label are printed on 100 percent FSC-certified paper.

MADE IN THE USA